AUBREY BEARDSLEY

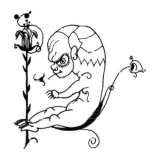

First published in Great Britain in 1998 by Brockhampton Press
a member of the Hodder Headline Group
20 Bloomsbury Street, London WC1B 3QA

ISBN 1-8601-9361-7

A copy of the CIP data is available from the
British Library upon request.

Designed and produced for Brockhampton Press
by Keith Pointing Design Consultancy.

Reprographics by Datum Digital Limited
Printed and Bound in Hong Kong.

AUBREY BEARDSLEY

ANDREW LAMBIRTH

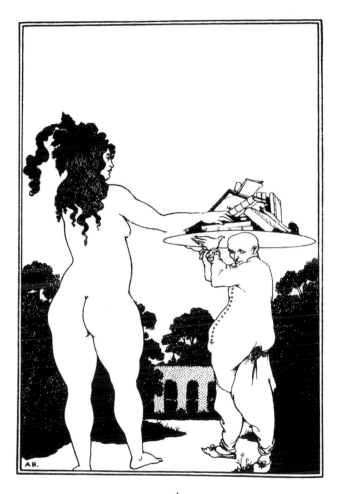

BROCKHAMPTON PRESS
LONDON

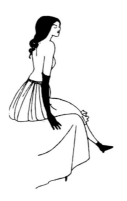

I T I S A S a superb and inventive draughtsman that Beardsley is remembered today. It scarcely seems credible that he was not yet 26 years old when he died, so great was his achievement. Almost single-handedly he brought book decoration, a branch of the applied arts, into the fine art arena. His genius showed that black and white drawing could not be dismissed as somehow less important than oil painting. Beardsley didn't exhibit the original drawings, for they were in fact made to be reproduced through photo line-block printing, a new technique invented in 1876. Prior to this, an artist's drawings had been copied by another craftsman onto woodblocks and then printed; the results were invariably diluted in character. By the 1880s, the new photo-mechanical process had taken over. Beardsley's drawing technique of clean lines and solid blacks was well-suited to line-block printing; the reproductions are singularly effective and faithful to the original. It was their wide dissemination through magazine publication that made Beardsley's name. It was very much a question of the right man being in the right place at the right time.

He grew up mostly in Brighton - a louche London by the sea, the favoured resort of illicit week-enders - before gravitating to London itself. Since he worked by day as a clerk in the Guardian Life and Fire Insurance Office (1890-2), Beardsley developed a habit of drawing at night by candle light. This remained his preferred mode: if he had to draw during the day he would pull the curtains and light the candles in a pair of massive gilt French Empire candlesticks. In matters of light, as in much else, he preferred the artificial to the natural.

For Beardsley, a formal art training was unnecessary. He attended a few evening classes at Westminster Art School, but he was primarily self-taught, referring constantly to Italian Renaissance masters. (His collection of prints after Mantegna's engravings travelled with him everywhere.) He was well-read, and passionate about books, but his art aspired beyond the merely illustrational. His extraordinary grasp of formal values - in other words, his supreme control of line and pattern - can be seen in the haunting drawings he made for *Salome*. Their provocative subject can be gauged by the fact that Beardsley had to re-work his original ideas (he was constantly being censored) and place a fig leaf over previously exposed genitals. Beardsley wanted to achieve fame, and to startle the bourgeois. He did both. Soon, even the satirical magazine *Punch* was parodying his work.

His first real break came in 1892, when, on good advice, the publisher JM Dent offered Beardsley £250 to illustrate Sir Thomas Malory's *Morte Darthur*. This was a considerable sum, three times Beardsley's salary as a clerk. But the project involved making 362 drawings (including borders and chapter headings) and took two years, long before which Beardsley, effectively bored, had outgrown its sub-medieval conventions. In comparison to what others were doing with books, for instance the Kelmscott Chaucer of William Morris and Edward Burne-Jones, Beardsley's designs cut through much of the archaic fussiness and over-ornamentation. If the book is still judged to be apprentice work, lacking the great originality of what was to come, it is yet redeemed by many remarkable individual drawings and a powerful cover design.

In 1893, a discerning article by the American critic Joseph Pennell in *The Studio* magazine first brought Beardsley to general notice. At once he aroused contrasting reactions: some were enchanted by his genius, others thought his drawings were unhealthy, the product of secret and shameful vice. A few years later, and the climate of taste had shifted again: the heady mixture of mischief and religious feeling which came to epitomise the 1890s was perceived to be largely the result of Beardsley's pen. Even before his death people spoke of it as the 'Beardsley period', and no less a luminary than the cartoonist and man of letters Max Beerbohm was responsible for the phrase. Oscar Wilde, the other great lion of the nineties and thus almost in competition with Beardsley, once claimed to have "invented Aubrey". Everyone was jumping on the aesthetic band-wagon. Then, with 1900, a new age dawned. The *fin de siècle* frenzy (akin in our own time to millennium fever) had abated, everything decadent was despised and distrusted, and Beardsley's reputation went underground. It was to surface later to even greater effect.

Physically, Beardsley was elegant but looked consumptive. He dressed impeccably in grey, with hair Max Beerbohm called "a kind of tortoise-shell". In a letter to his former schoolteacher Beardsley wrote: "I am 18 years old, with a vile constitution, a sallow face and sunken eyes, long red hair, a shuffling gait and a stoop." Already the ill-health which was to plague him and to cause his early death was visible in his appearance. Wilde, for instance, described him as having a "face like a

silver hatchet". Aware that time was short, Beardsley was quick-talking and feverishly creative. The remarkable thing is the exactitude of his drawing, its cool precision, given the hectic pace of his life.

Following up Pennell's laudatory article, the publisher John Lane offered Beardsley 50 guineas to design 10 illustrations for Oscar Wilde's banned play *Salome*. This was another advantageous deal, especially considering that Wilde's royalties from the publication, at most, would total £40. Beardsley was the talk of the town, and it was at this point that Lane decided to launch a quarterly publication to celebrate avant-garde Nineties taste, engaging with such burning issues as sex and the role of women. This was *The Yellow Book*, of which Beardsley was appointed art editor.

Beardsley made over 600 drawings in the five short years of his professional career, but he was really only successful financially for the few months of his reign as art editor of *The Yellow Book* (1894-5). It was then that he moved to 114 Cambridge Street in Pimlico with his sister and mother. (He never married. His mother was to nurse him to the end of his life; she believed in him completely and never for a moment thought his work indecent.) In Pimlico, Beardsley had the drawing room distempered in violent orange with a black trim. In such surroundings he could entertain and shock his guests by hanging on the walls a series of small intensely erotic black and white prints from a 'Pillow Book' by Utamaro. When the Beardsleys left Cambridge Street, they abandoned much of

their furniture, including Beardsley's drawing table. In future they travelled light.

In 1895 Oscar Wilde was imprisoned for homosexual offences; at once the reactionary turned on *The Yellow Book* (though ironically Wilde had never contributed to it) and literally stoned its offices. Beardsley, inseparable from Wilde in the public mind, was unfairly sacked in a moment of panic. What was he to do? He was lucky to find another publisher, Leonard Smithers, who specialised in erotica, and to form an agreement with him. The very next year Smithers shrewdly brought out an alternative to *The Yellow Book* at half the price, again with Beardsley as art editor, and called it *The Savoy*. This was the period of some of Beardsley's best work. Other publications include his illustrations for Pope's *Rape of the Lock* and for Aristophanes' *Lysistrata,* both of which appeared in 1896. It was to be his last full working year.

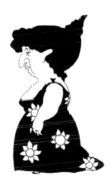

There are several distinct Beardsley styles, each evolving swiftly one from the other. After the Burne-Jones influenced medievalism there was the early fantastically fine 'hairline' style, like a cobweb or a caterpillar's hairy back. Then came the more pared-down *Japonisme* of *Salome.* (In the 1870s and 80s Japanese prints had been gathering popularity. Beardsley's radical cropping of the image, which both Degas and Lautrec - and to a lesser extent van Gogh - used to great effect, is taken from the Japanese.) With the drawings for *The Rape of the Lock,* Beardsley consciously returned to the 18th century. This intricate

hatched-line style resembled embroidery and derived largely from French copperplate engravings after such painters as Watteau, Lancret and Pater. Elegant and stylish though this period is, it does not have the hard edges and vitality of shape present in *Salome.* If this is Beardsley's version of rococo, he was to venture in his final drawings (for *Volpone*) into a rich baroque, all subtly-shaded pencil gradations.

With the *Lysistrata* designs, Beardsley returned to the outline with a vengeance, this time even leaving his backgrounds blank. These masterly illustrations are tightly drawn, with a certainty that matches their drastic simplification. They have a beauty and economy of mark which perhaps derives ultimately from Celtic ornament - the kind of virtuoso tracery found in illuminated manuscript design. But what of the story? Was Beardsley simply dirty-minded? In truth he was a mass of contradictions: master of the clean line and the unclean subject; the sophisticate about whom the novelist Brigid Brophy could write so tellingly - "his vision is permanently that of a child lying in bed watching his mother dress for a dinner party"; the divided nature one friend described as "like wrought iron and like honeysuckle".

Beardsley was adept at drawing the grotesque in the 17th century manner, which he mixed cleverly with the Japanese illustrative tradition. He was obsessed with drawing an ancient and sinister embryo in attendance on youth and beauty; it is part-foetus, part self-

portrait. He himself referred to this motif in a letter as "an unstrangled abortion". Perhaps some unhappy personal event gave rise to it. (There is rumour of an incestuous union with his sister.) It is an image of which a 20th century Surrealist might have been proud.

Meanwhile the mortal ravages of tuberculosis made Beardsley increasingly feeble. Unable at last to draw with India ink on medium-grade cartridge paper, his preferred materials, he is said to have flung his favourite gold-nibbed pen across the room in anger; it stuck, quivering, in the floor.

Aubrey Beardsley died destitute on the 16 March 1898, in the south of France, a convert to Catholicism. According to the Public Record office, he possessed "absolutely nothing but a few clothes", whilst owing nearly £50 to his tailor. He was only 25 years old. Would he have gone on to become a painter? There are only two existing oils by Beardsley (in fact the two sides of the same canvas, now in the Tate Gallery) which only show him flirting with the medium, aware no doubt that he hadn't the time to master it.

There was always a strong structural understanding in Beardsley's drawing, indeed it is his genius for composition which accounts for much of his pictorial success. Kenneth Clark reckoned that Beardsley's few months in an architect's office at the very beginning of his career was the only training to affect him. (It was in fact the Clerkenwell

District Surveyor's Office.) "Not only are the architectural settings in his drawings done with professional knowledge," wrote Clark, "but there is in many of them an architectural sense of space which was to influence one of the founders of modern architecture, Charles Rennie Mackintosh." Beardsley, who is quoted as saying "nothing depresses me as much as a Gothic cathedral", might have made a wonderful modern architect. Equally, as a traveller and talented linguist, he might have ended up in Germany attached to the Bauhaus design school.

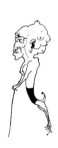 What of Beardsley's influence? Diaghilev admired him, and it was through him that Bakst came to know Beardsley's work and draw upon it for his set designs. Picasso made Beardsley pastiches in the 1890s, and both Kandinsky and Klee were crucially aware of him. Munch's prints owe a great deal to Beardsley's ground-breaking design. The most far-reaching Beardsley revival was in the 1960s, with a huge exhibition in London and America. Cecil Beaton dressed and designed the Ascot scene in *My Fair Lady* (1964) in Beardsley black and white, and Luchino Visconti's production of *La Traviata* (1969) was done in the Beardsley manner. A number of commentators remarked how Beardsley's sense of design anticipated hard-edge abstract painting, while his imagery became the subject of affectionate pastiche and poster design.

One hundred years ago, the art critic and champion of Beardsley DS MacColl wrote this: "It is characteristic of a good deal of our modern art that it attempts to give us the maximum of thrill, of nerve-disturbance with a minimum of reason for it, that it seeks for a nightmare intensity by estranging the terms in which ideas or sensations are presented."

How appropriate are his words today when applied to our Young British Artists. Think of Damien Hirst's shark. It is not so much a sculpture as an exercise in shock tactics. There is no idea behind it: the work is as unthinking as the dead shark itself.

Beardsley the aesthete believed in beauty, unlike so many of today's artists who seem to embrace a kind of despairing nihilism. Beardsley had his fantasies, but the YBAs have nightmares. André Breton, the self-appointed Pope of Surrealism, complained in 1966 that it was no longer possible to shock people. The recent furore over Marcus Harvey's portrait of Myra Hindley proves this not to be the case. Are we approaching a new puritanism? It is revealing to note that three of Beardsley's *Lysistrata* prints were confiscated by Japanese Customs officials and prevented from hanging in the 1998 Beardsley retrospective exhibition in Japan. Evidently, they still have the power to shock.

Perhaps the finest tribute to Beardsley came from Oscar Wilde, whose relations with him were stormy to say the least. Hearing of Beardsley's death Wilde wrote to Smithers: "Supremely premature as the flowering of his genius was, he still had immense powers of development, and had not sounded his last stop. There were great possibilities always in the cavern of his soul."

ANDREW LAMBIRTH LONDON, MARCH 1998

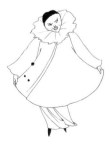

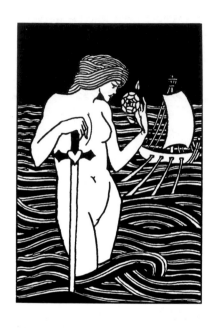

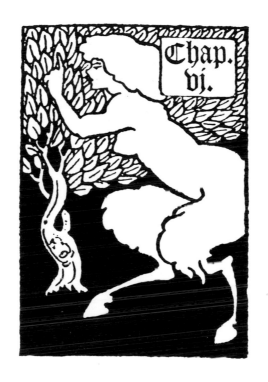

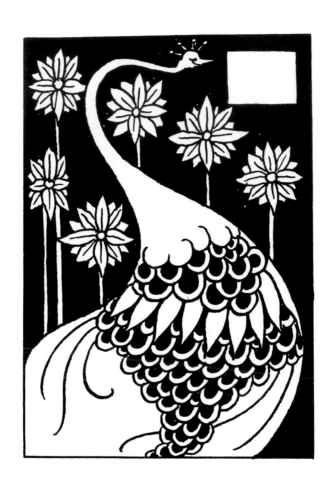

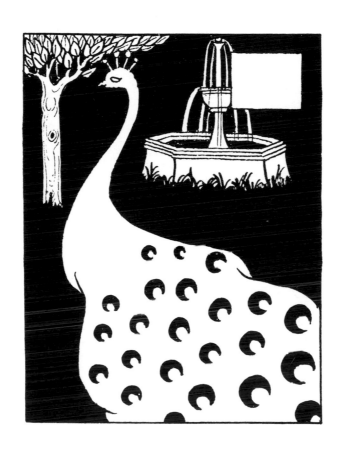

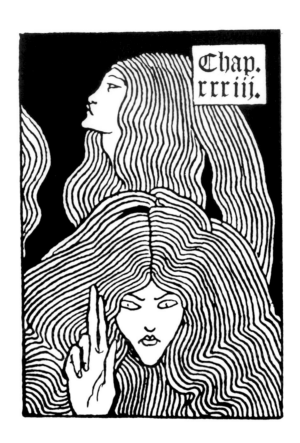

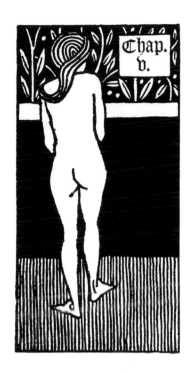

The image contains the text: Chap. V.

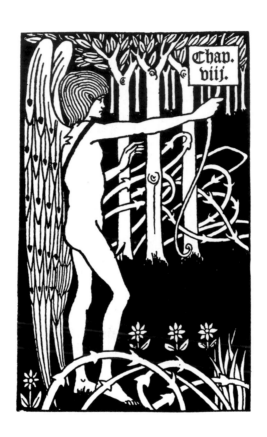

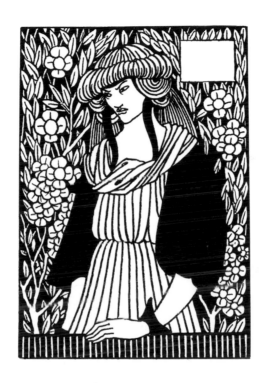

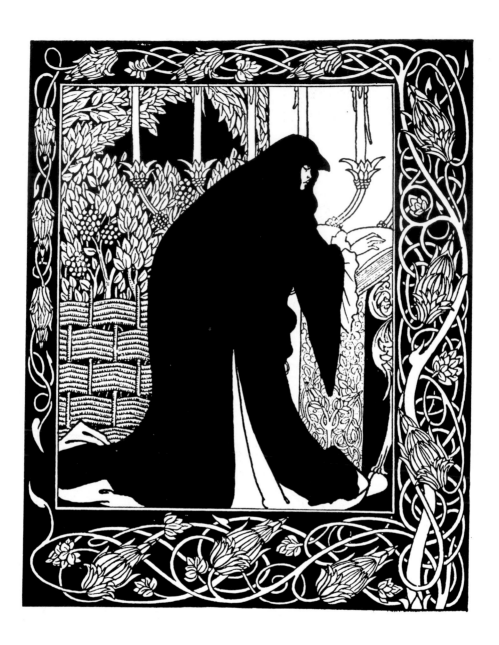

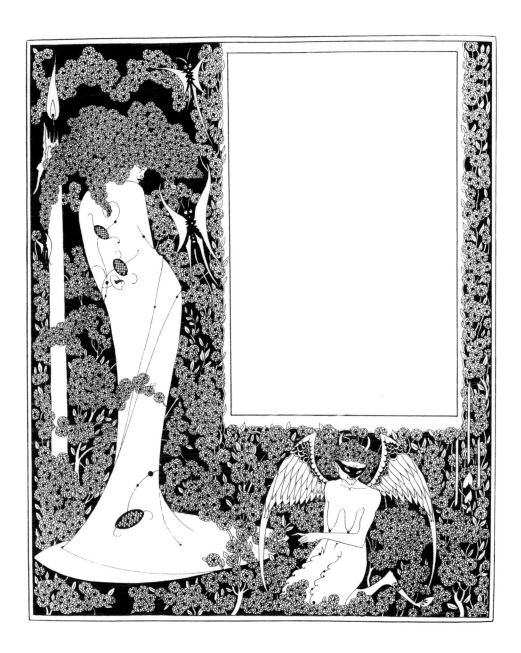

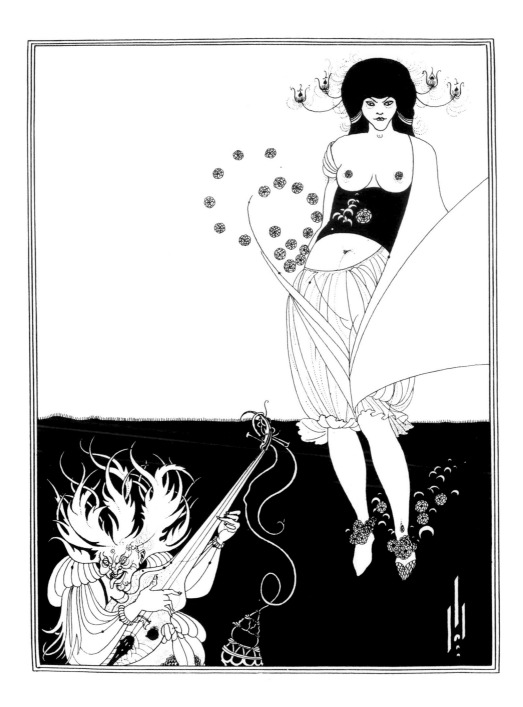

28

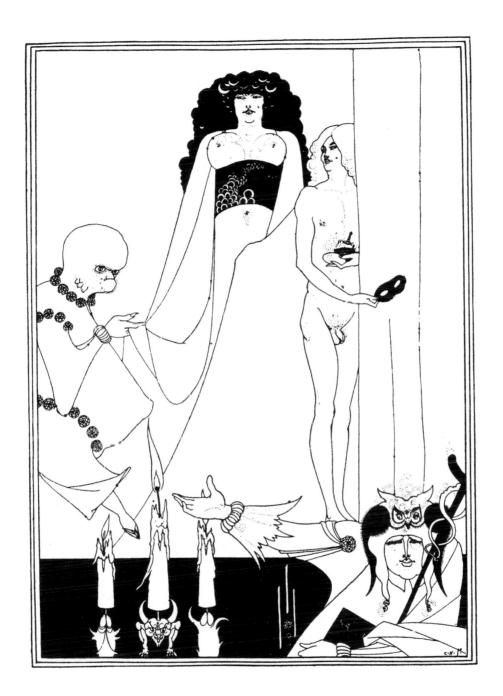

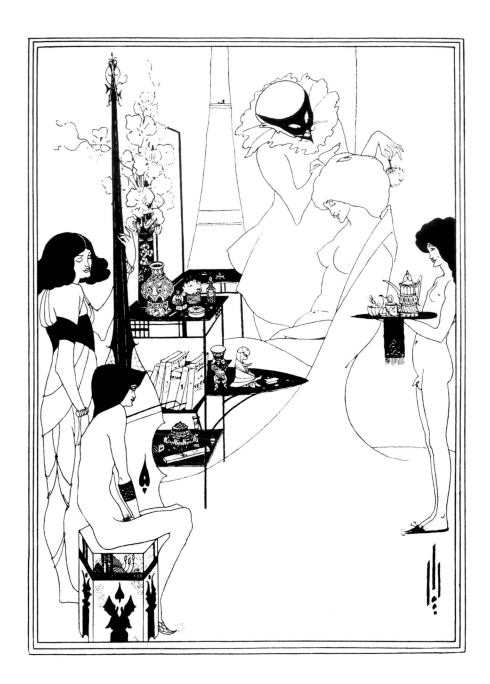

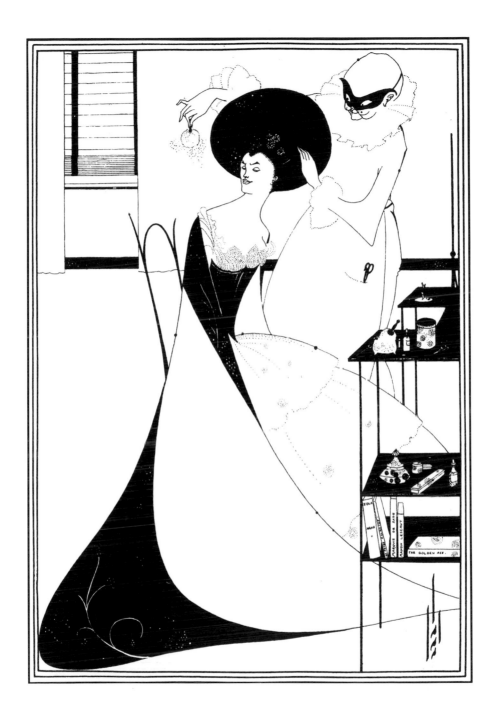

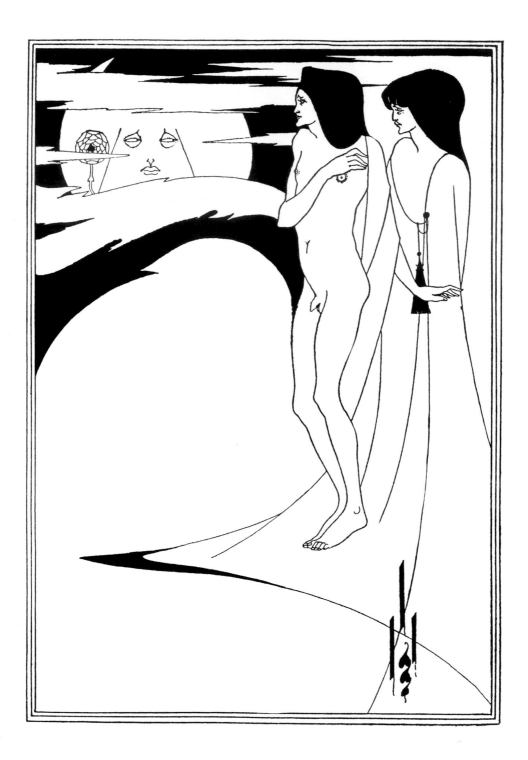

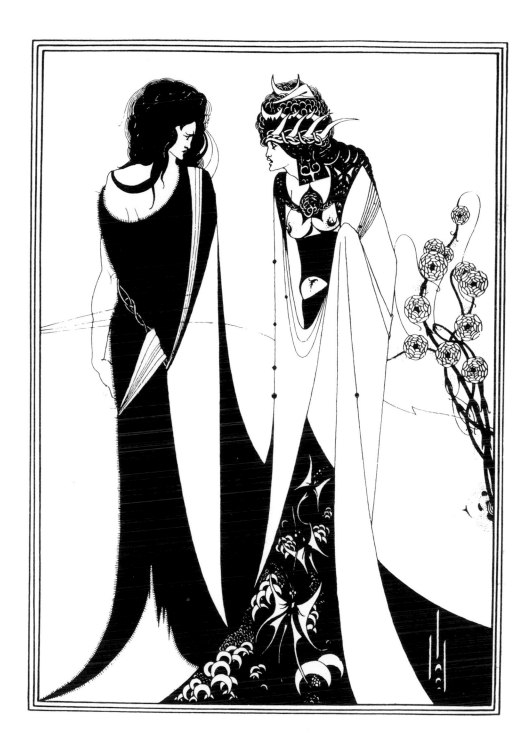

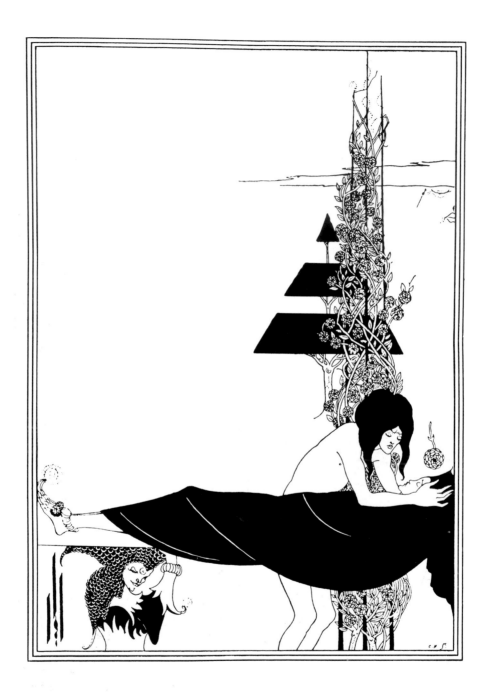

34

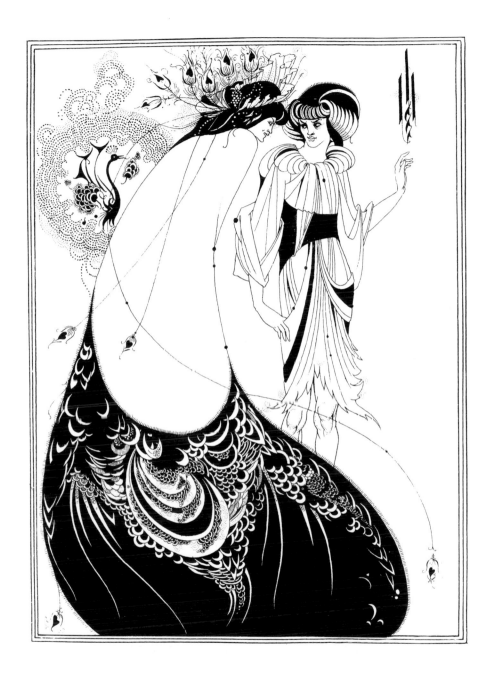

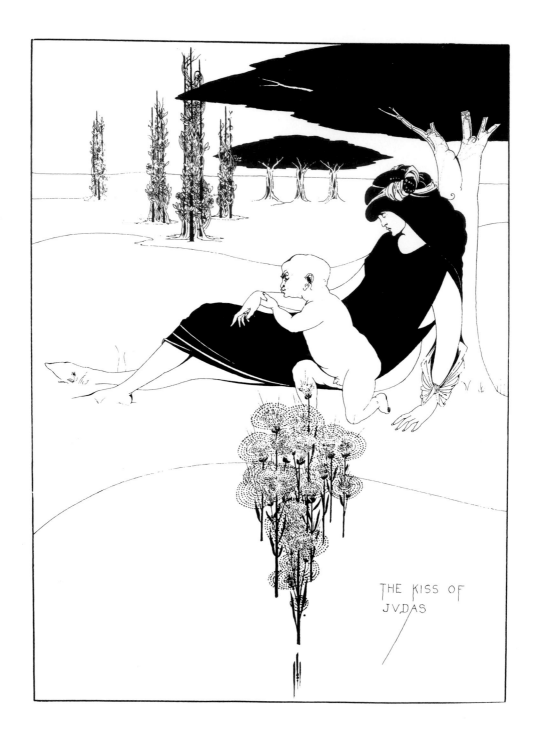

THE KISS OF
JUDAS

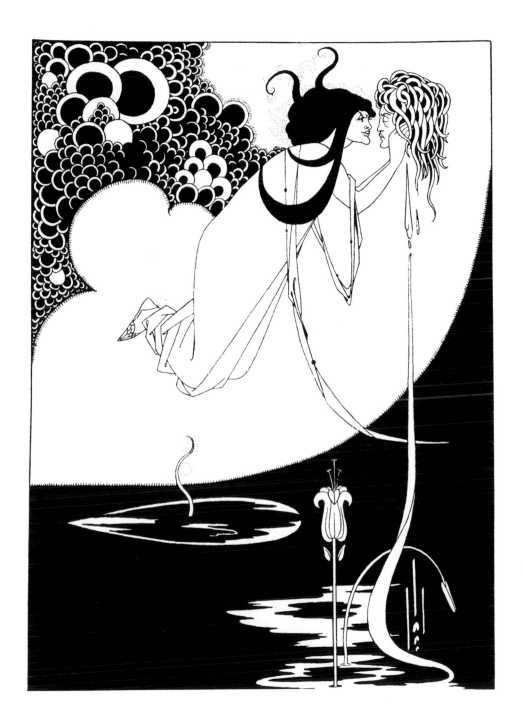

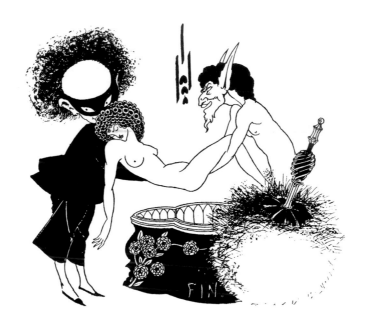

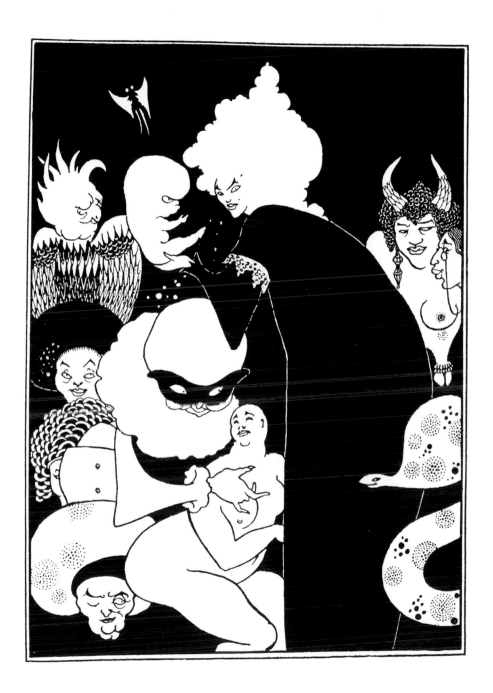

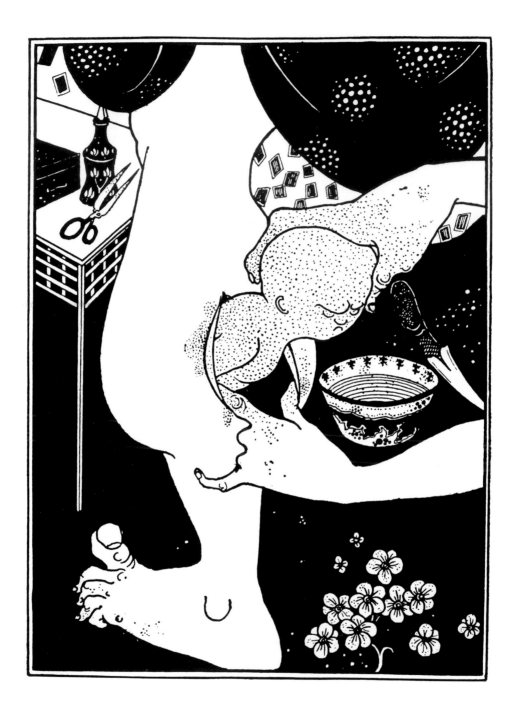

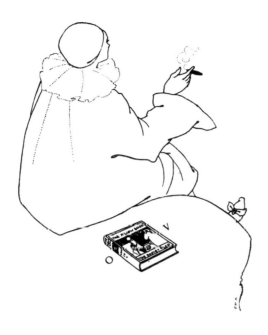

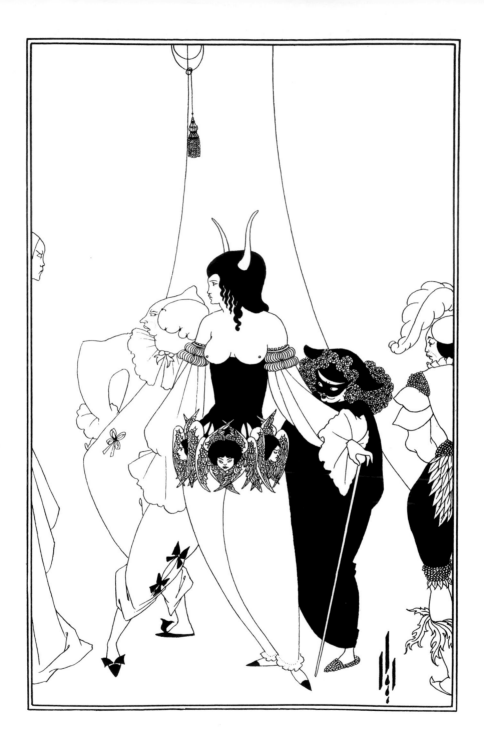

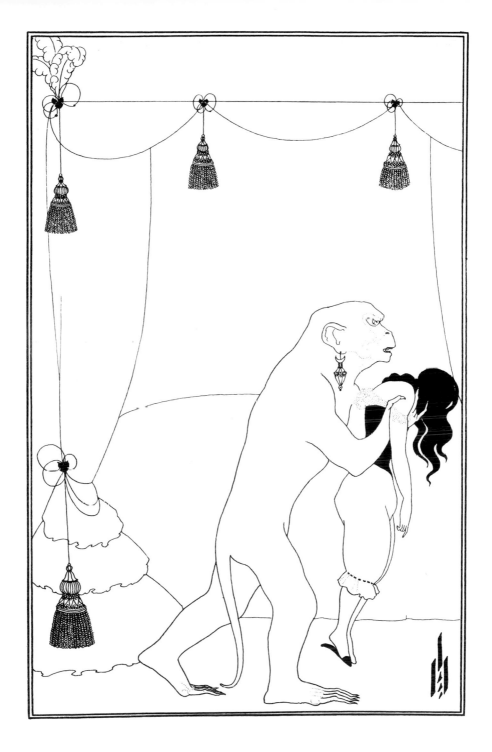

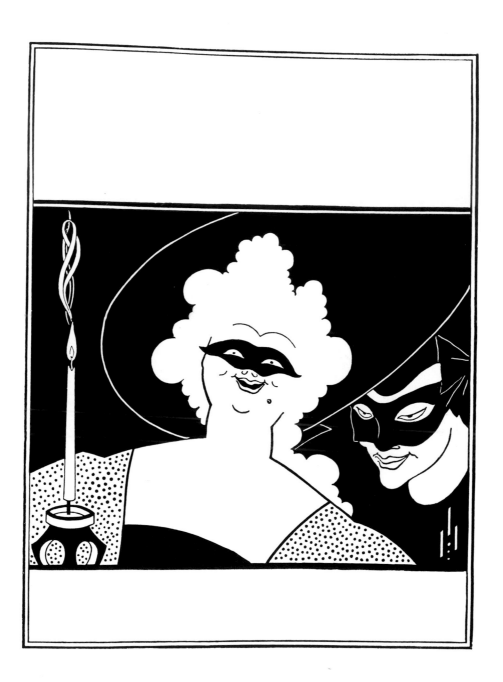

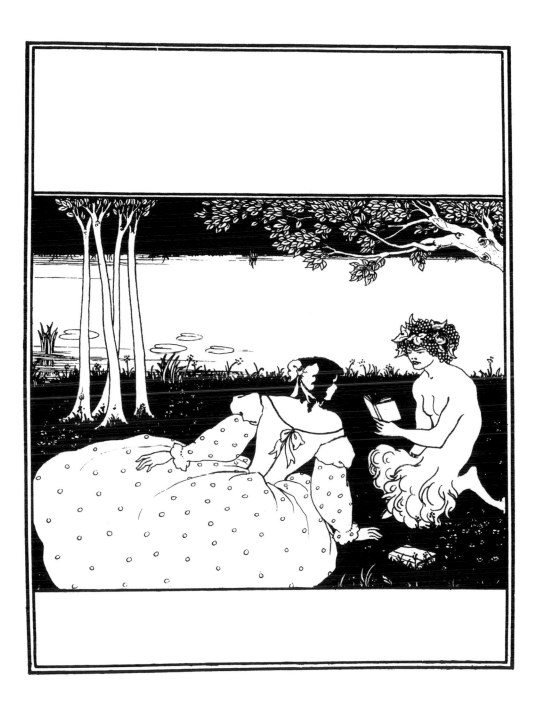

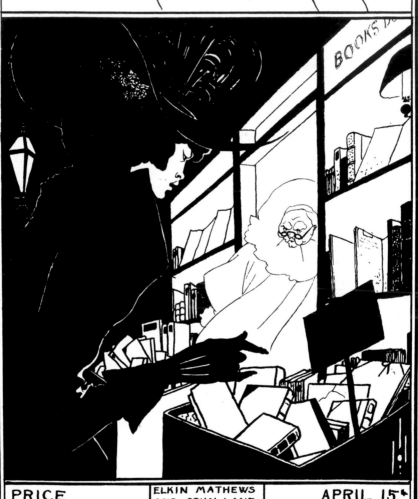

THE YELLOW BOOK.

AN ILLVSTRATED QVARTERLY.

PRICE FIVE SHILLINGS

ELKIN MATHEWS AND JOHN LANE, THE BODLEY HEAD VIGO ST. LONDON.

APRIL 15ᵗ MDCCC XCIV.

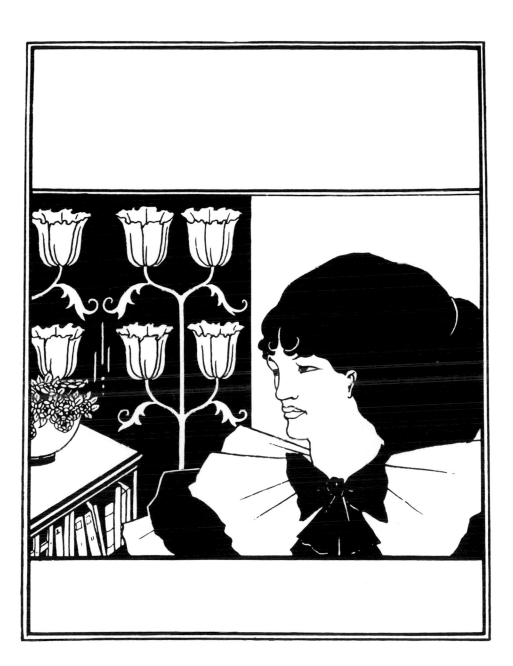

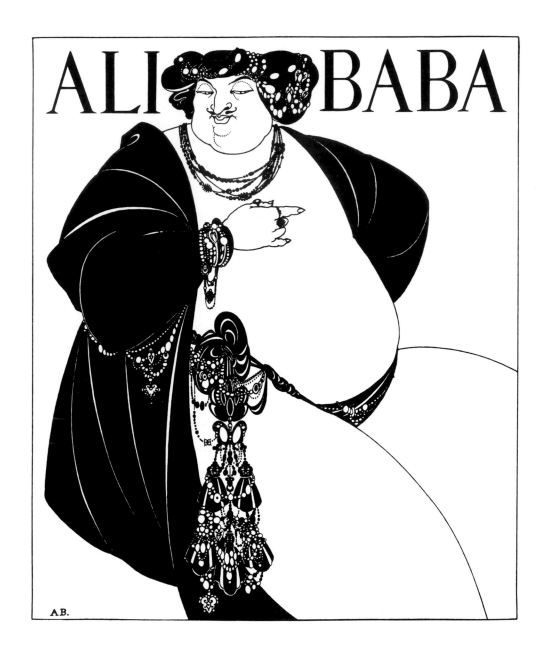

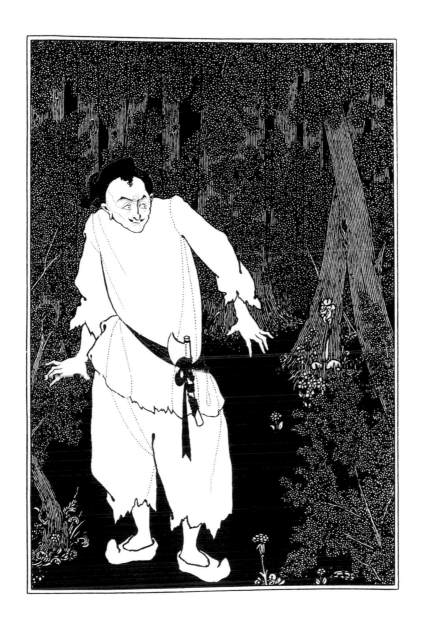

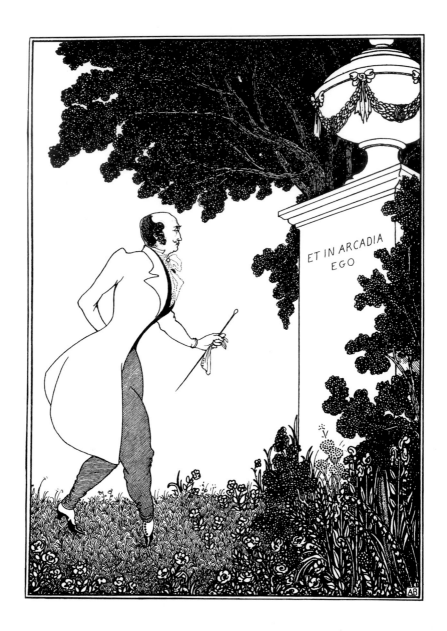

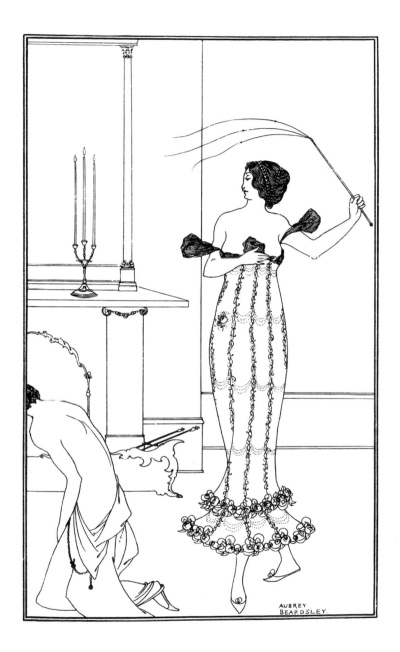

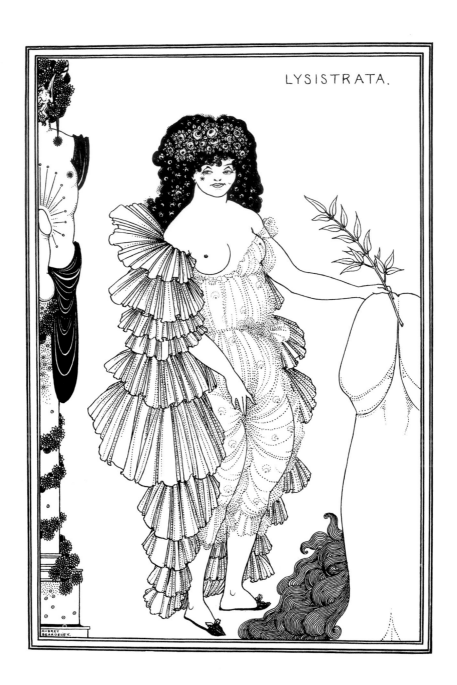

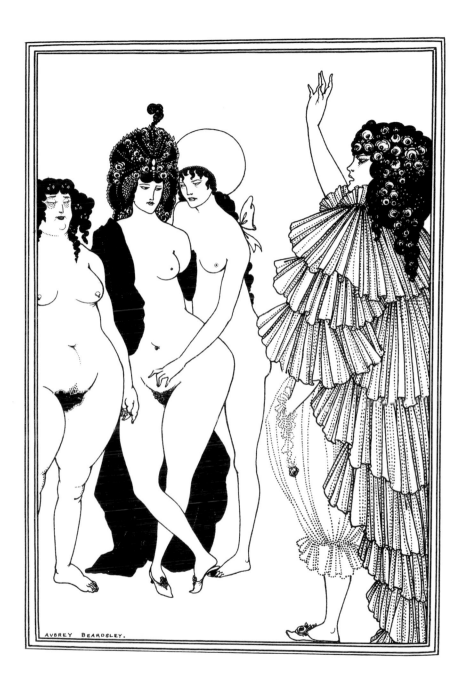

AUBREY BEARDSLEY.

53

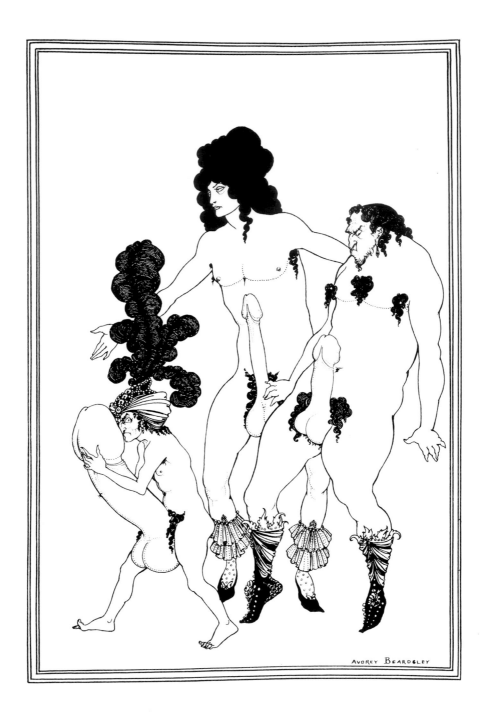

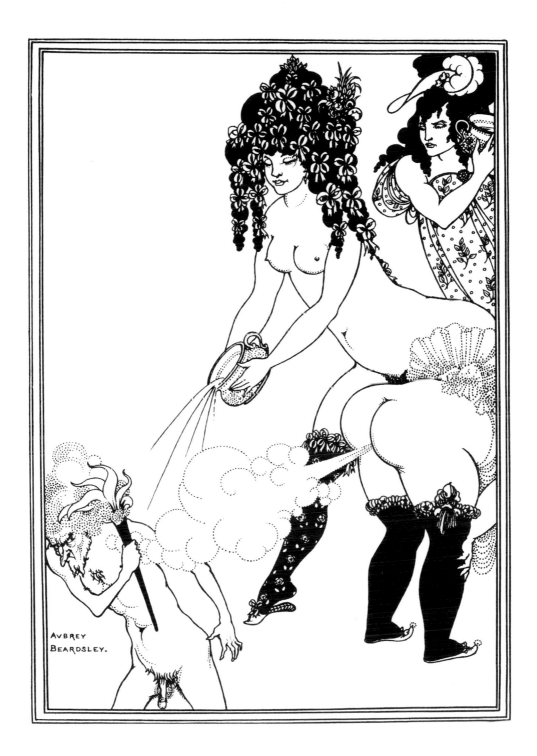

AVBREY
BEARDSLEY.

55

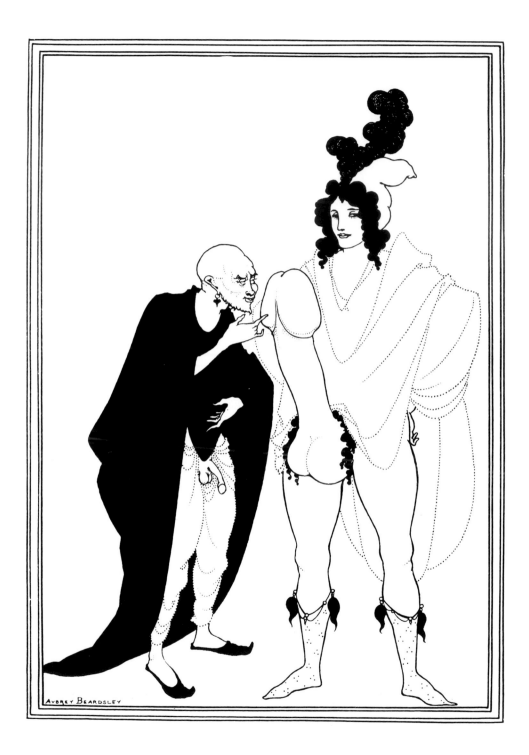

AUBREY BEARDSLEY

56

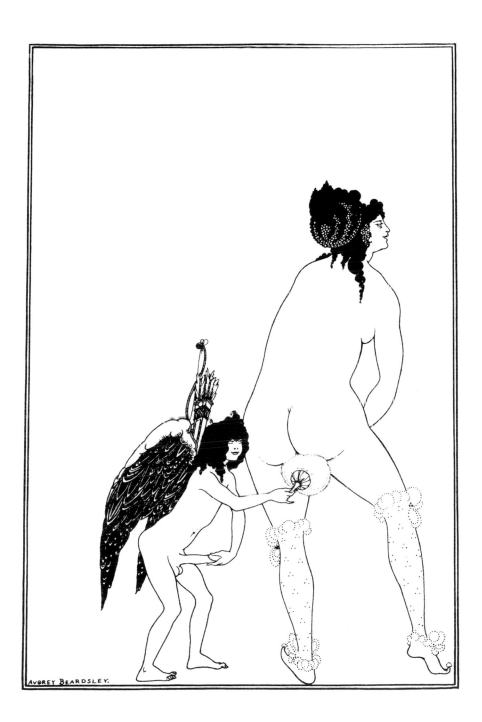

AVBREY BEARDSLEY.

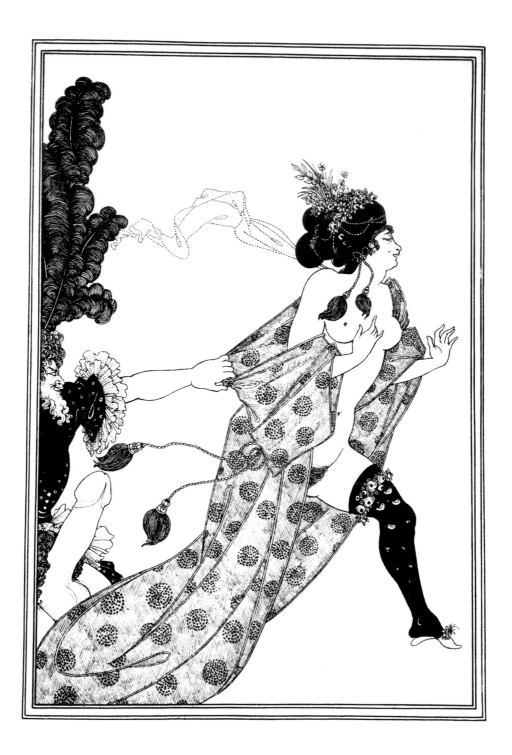

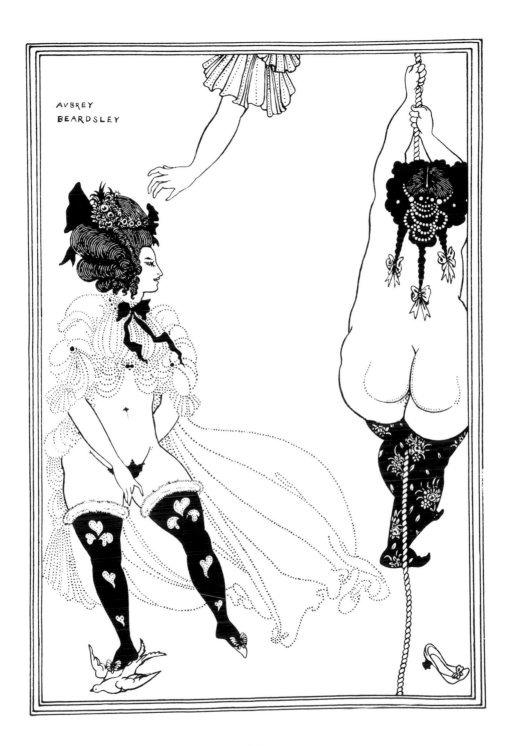

AVBREY
BEARDSLEY

59

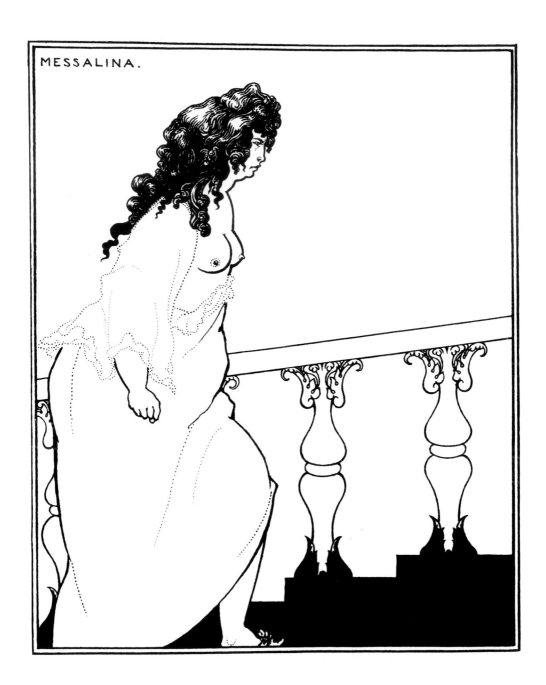

MESSALINA.

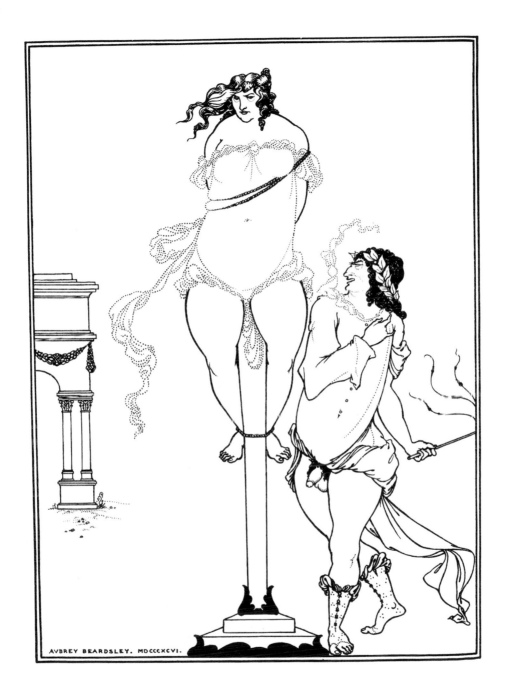

AVBREY BEARDSLEY. MDCCCXCVI.

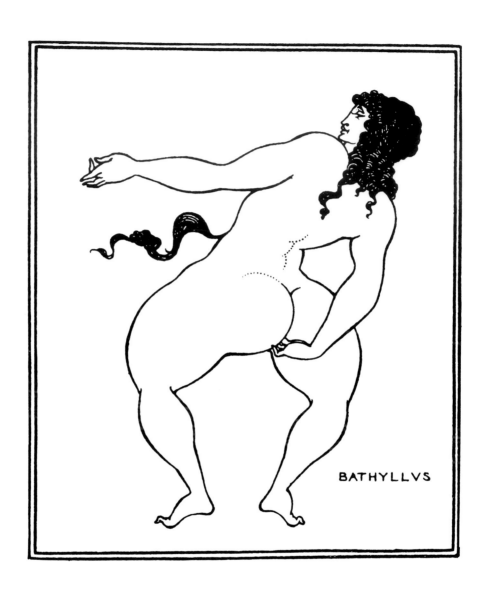

BATHYLLVS

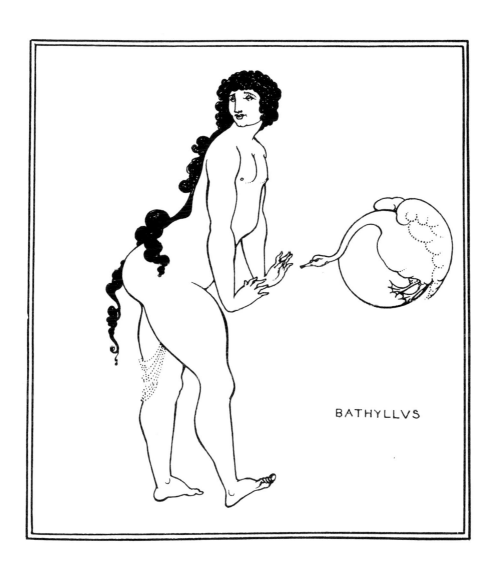

BATHYLLVS

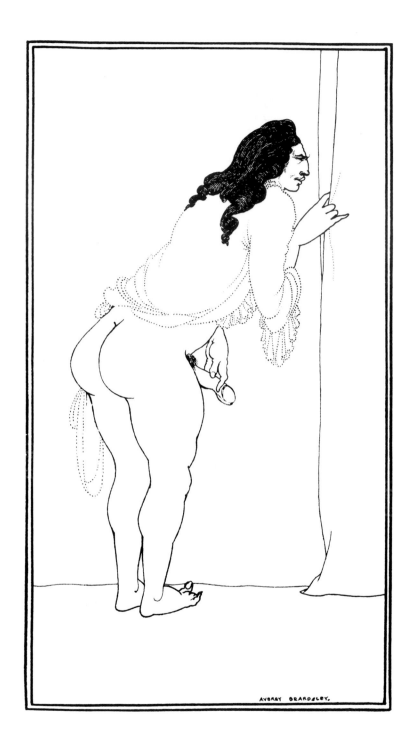

64

LES LIAISONS DANGEREUSES.

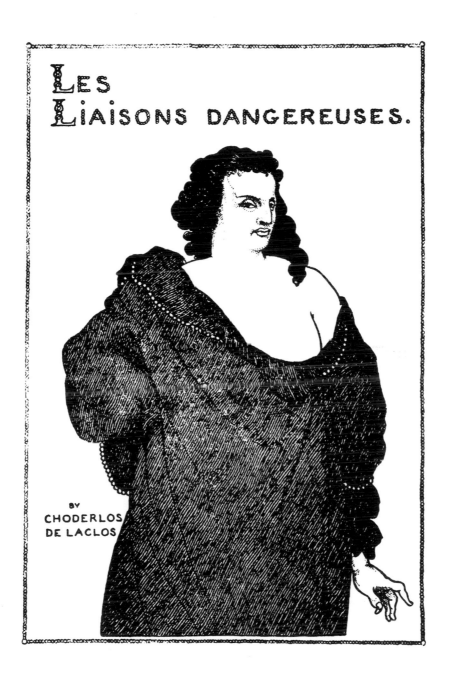

BY
CHODERLOS
DE LACLOS

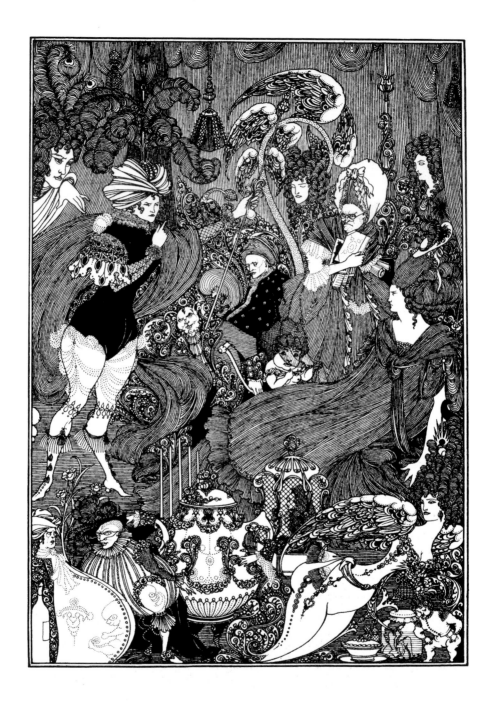

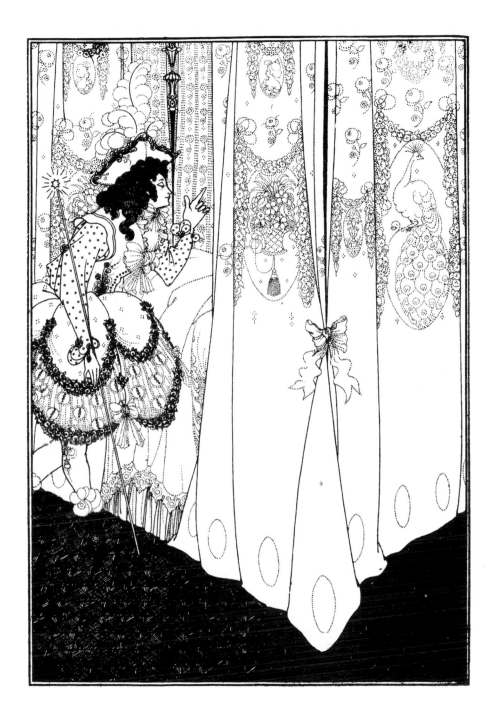

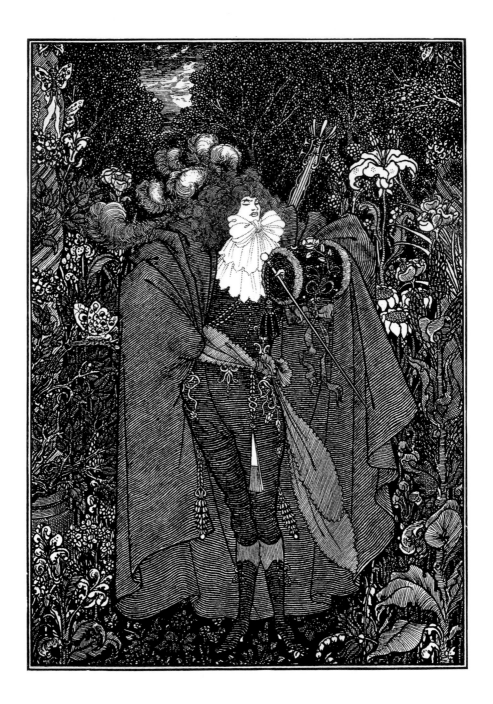

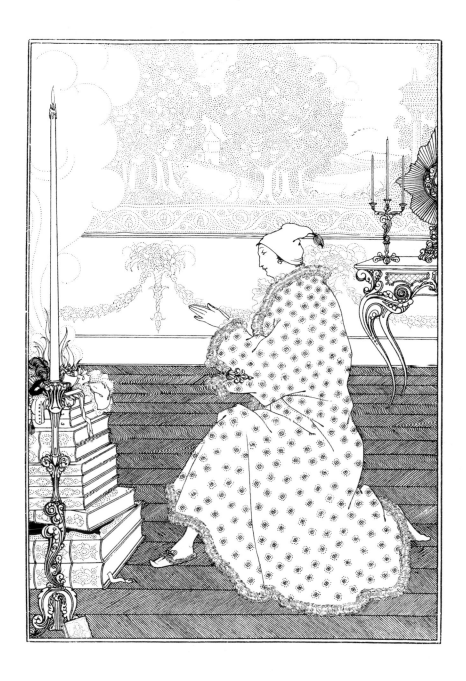

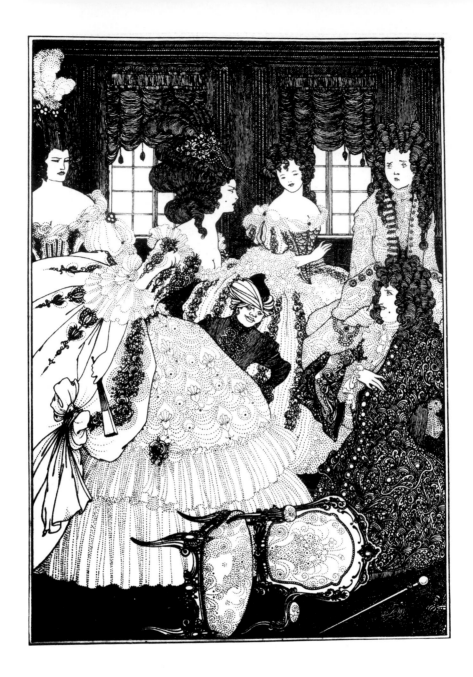

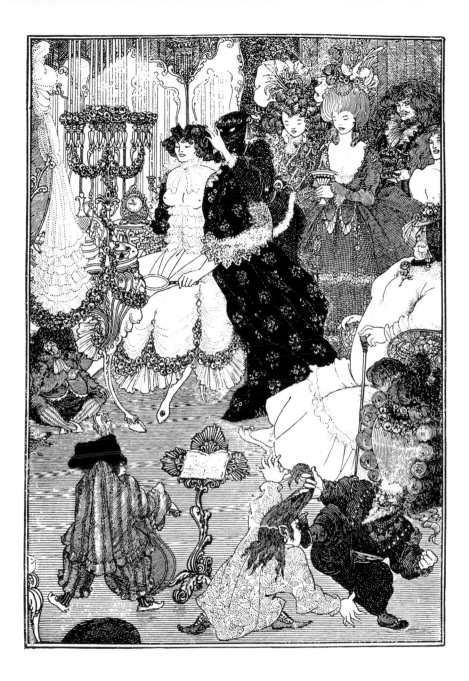

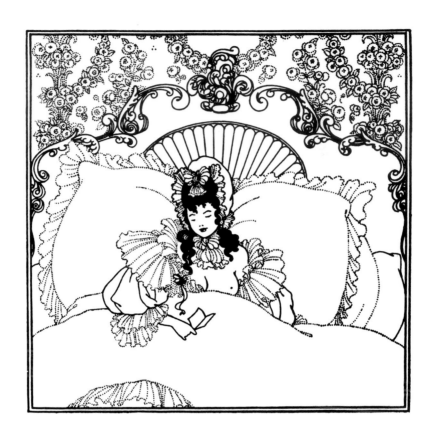

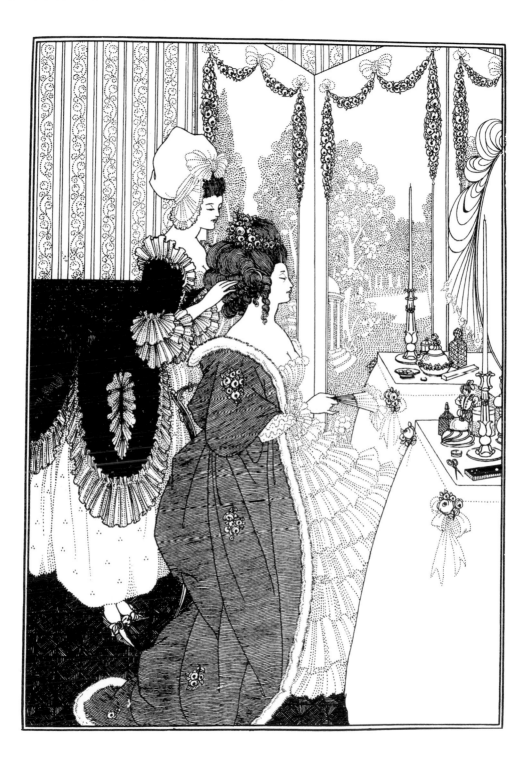

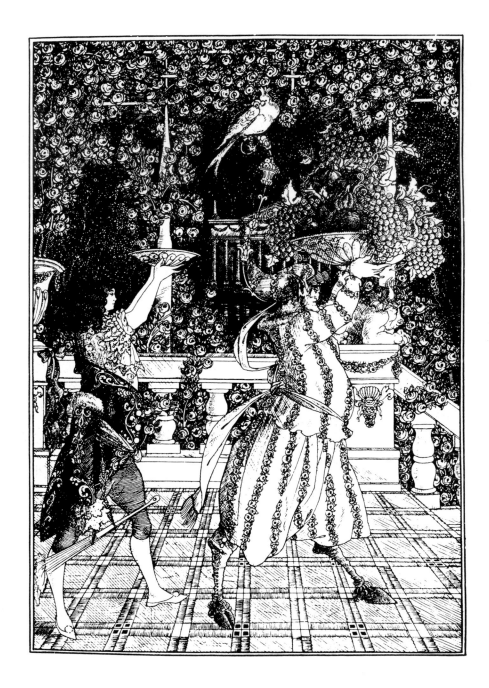

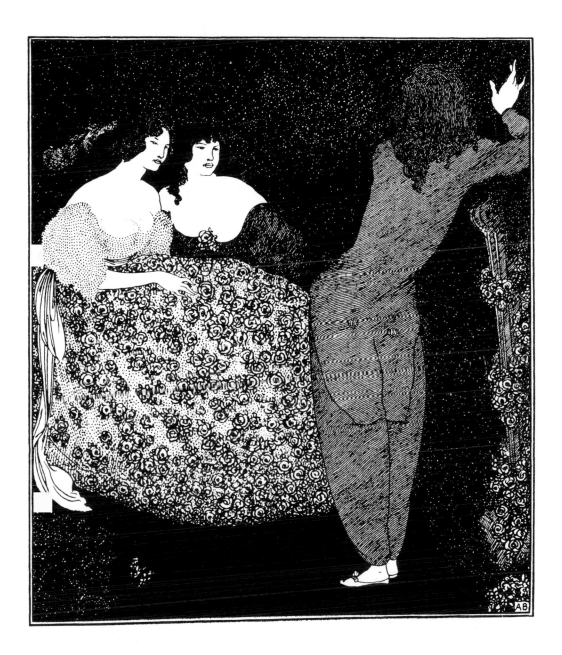

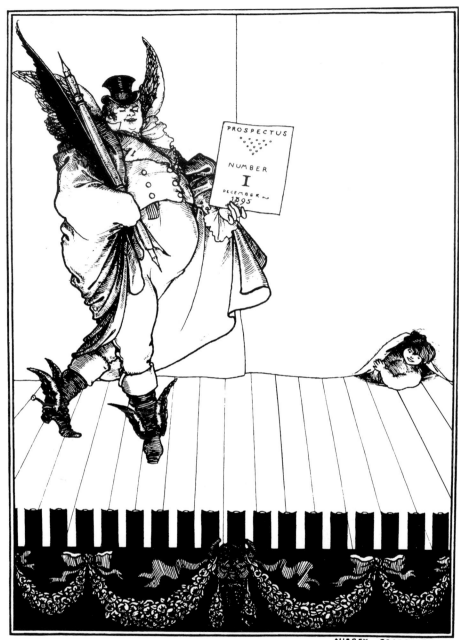

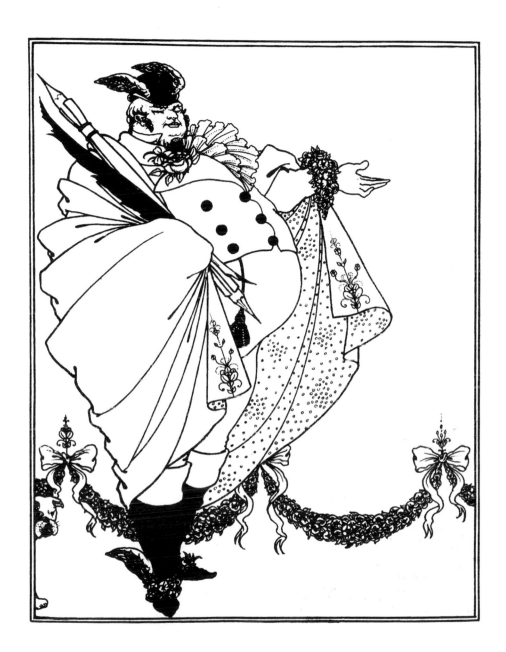

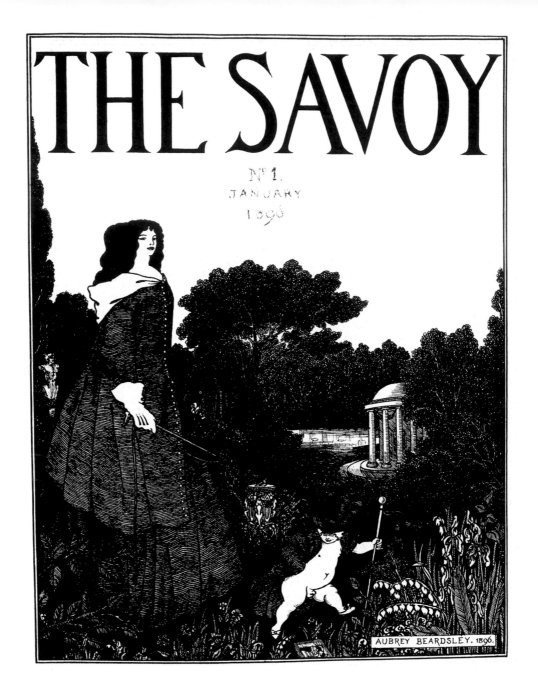

THE SAVOY

Nº 1.
JANUARY
1896

AUBREY BEARDSLEY. 1896.

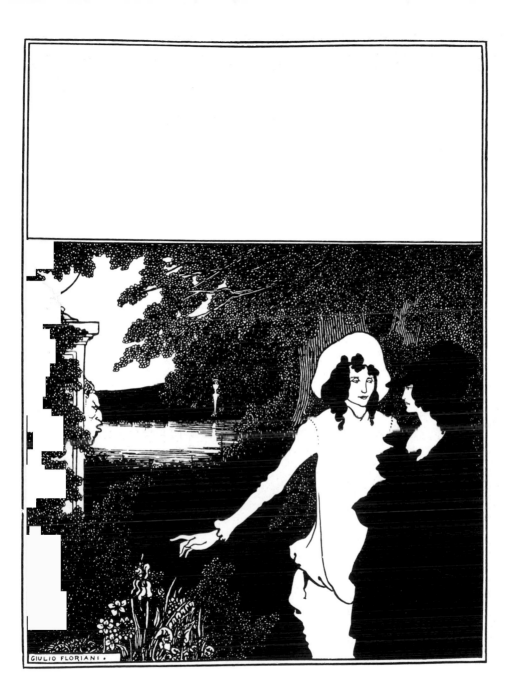

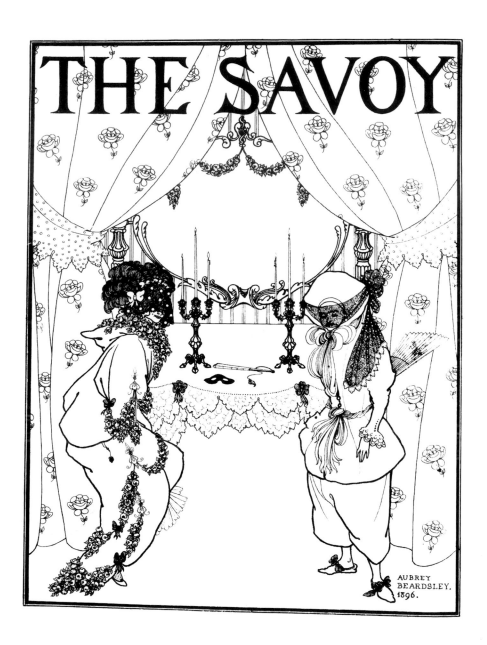

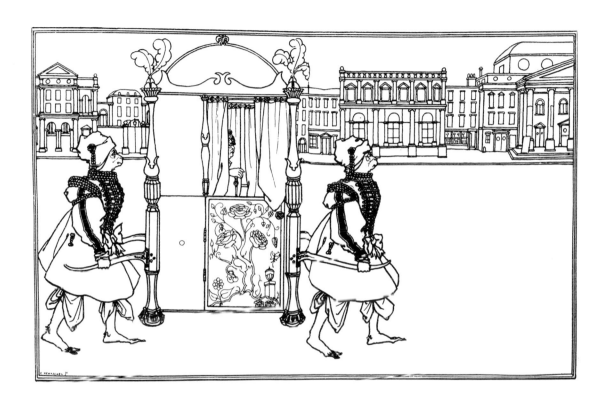

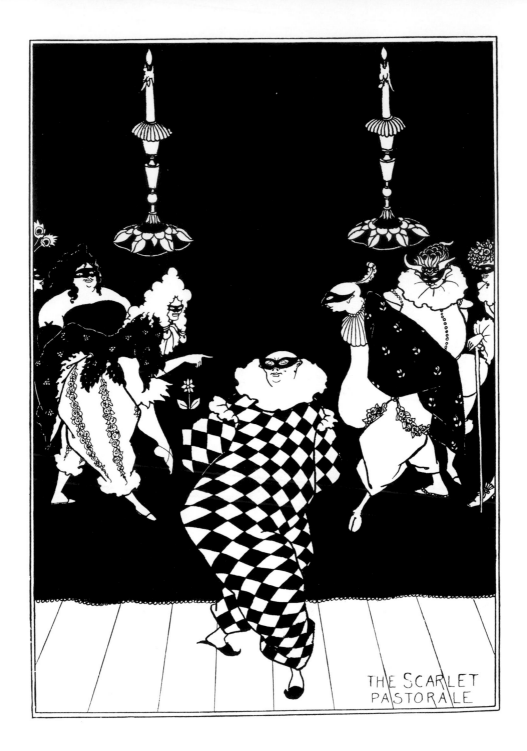

THE SCARLET
PASTORALE

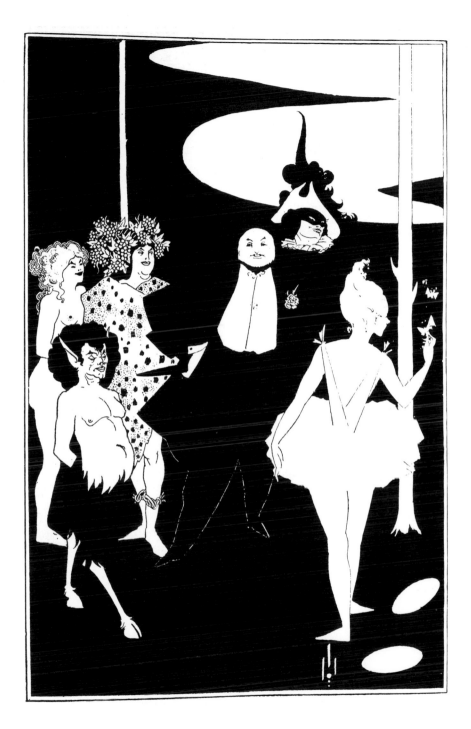

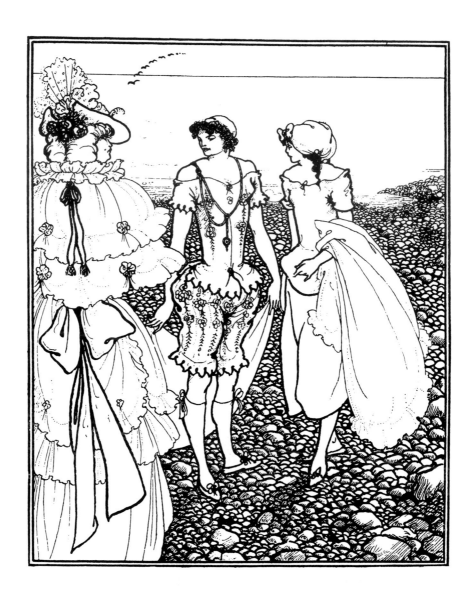

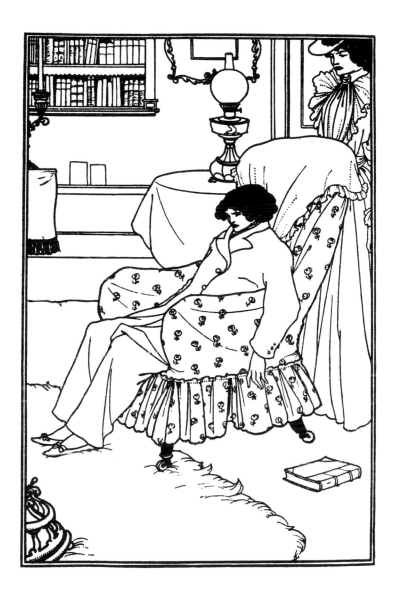

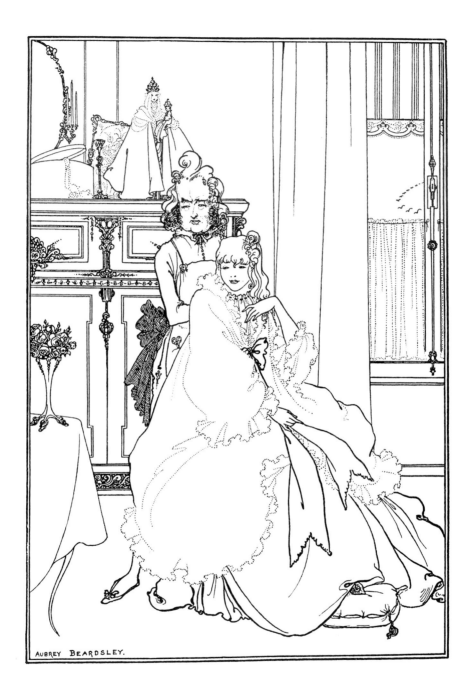

AUBREY BEARDSLEY.

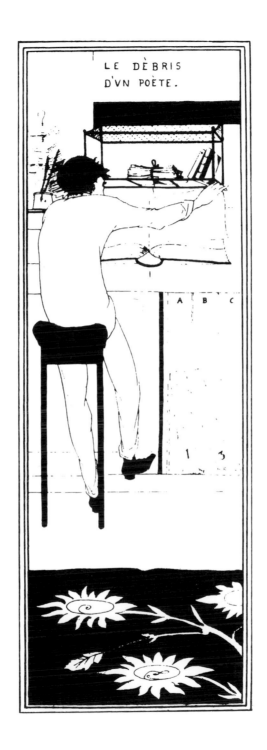

LE DÈBRIS
D'VN POÈTE.

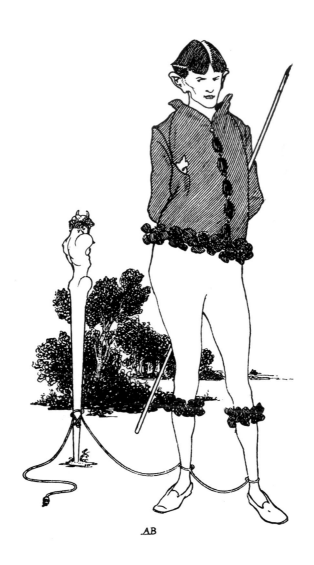

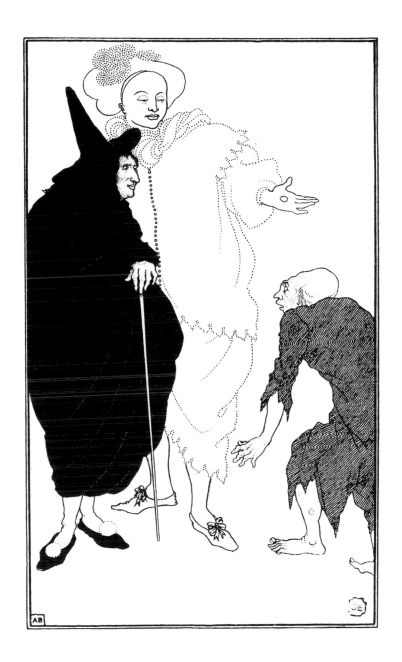

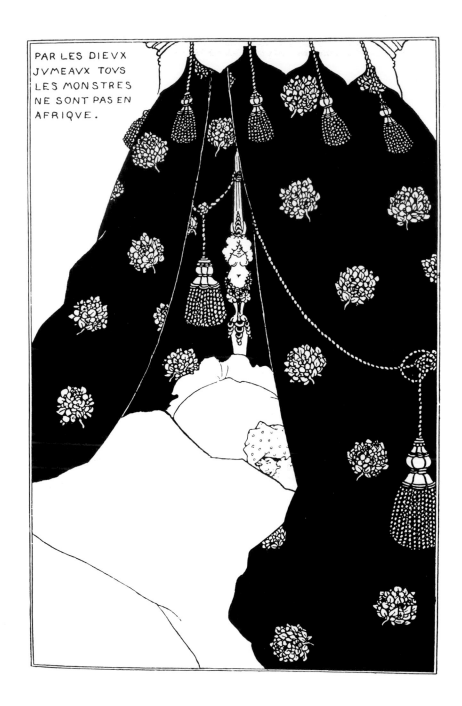

PAR LES DIEVX
JVMEAVX TOVS
LES MONSTRES
NE SONT PAS EN
AFRIQVE.

AUBREY BEARDSLEY

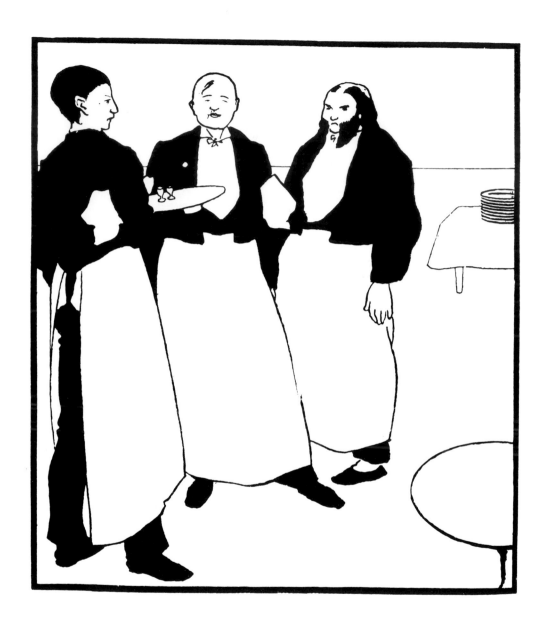

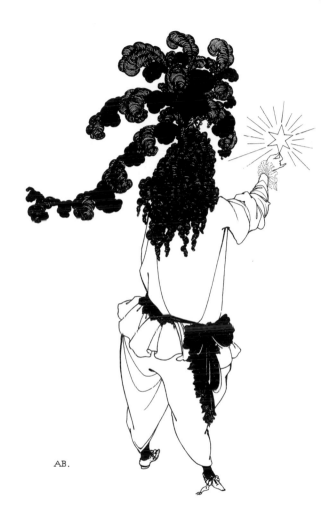

AB.

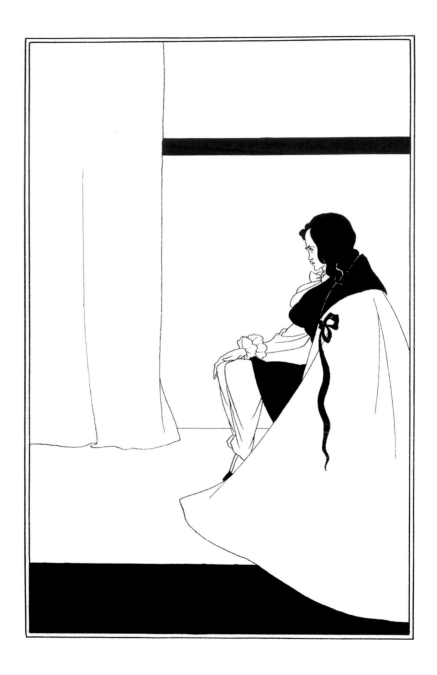

A BOOK OF FIFTY DRAWINGS
BY
AVBREY BEARDSLEY

AVBREY
BEARDSLEY

LONDON
LEONARD SMITHERS
ROYAL ARCADE. W
1897.

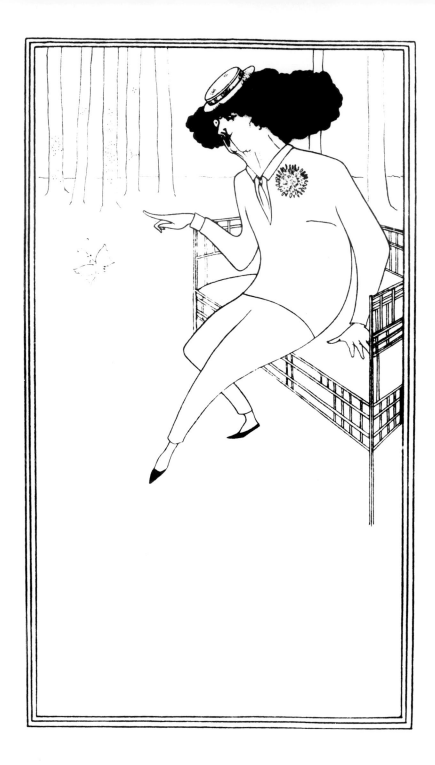

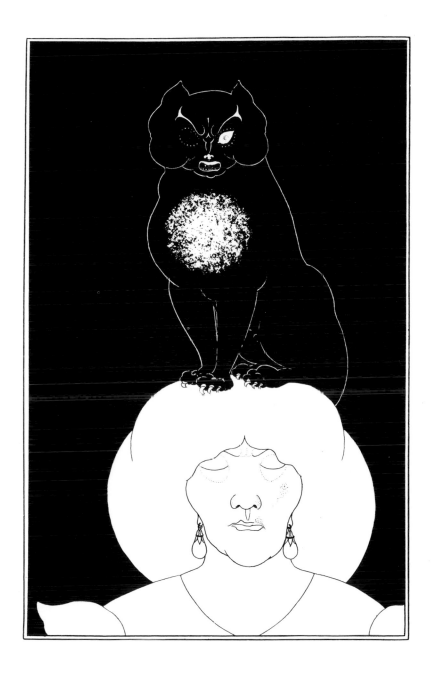

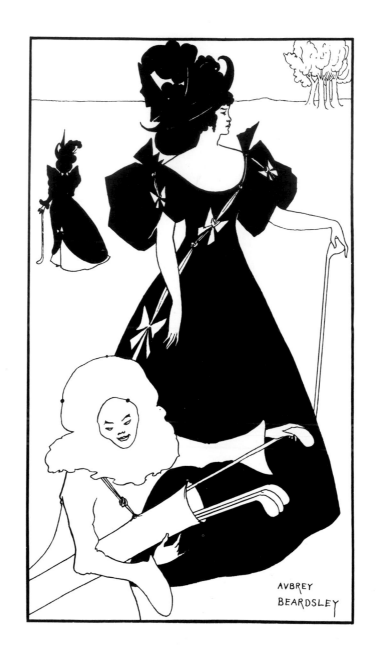

AVBREY
BEARDSLEY

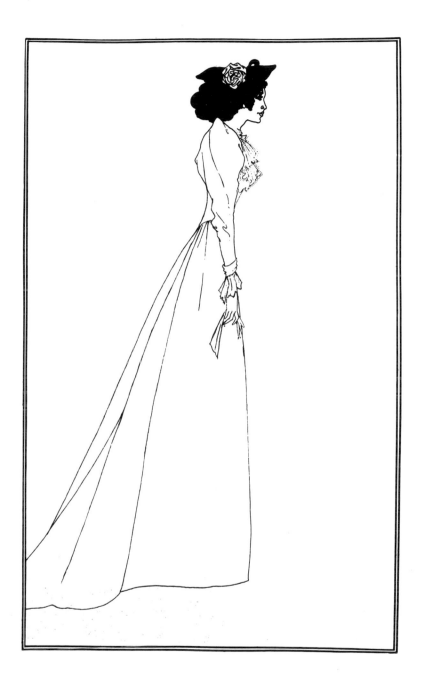

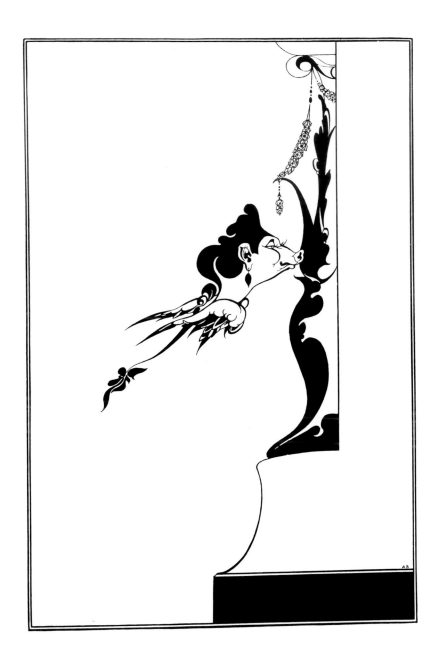

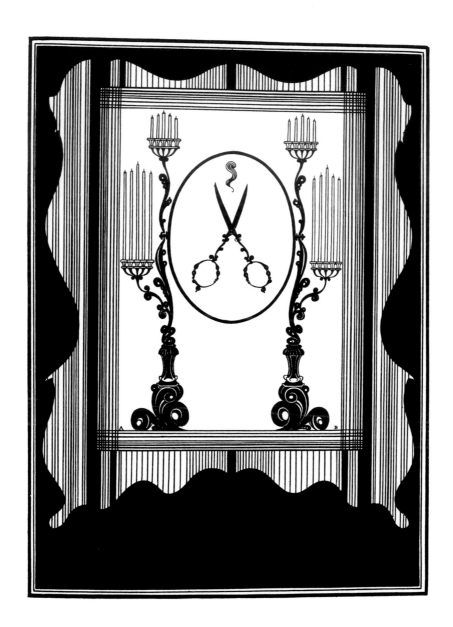

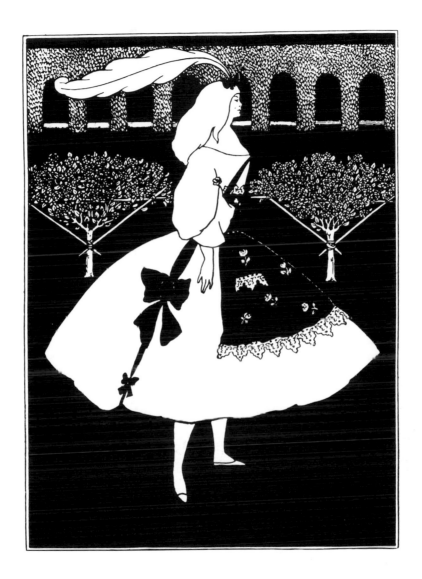

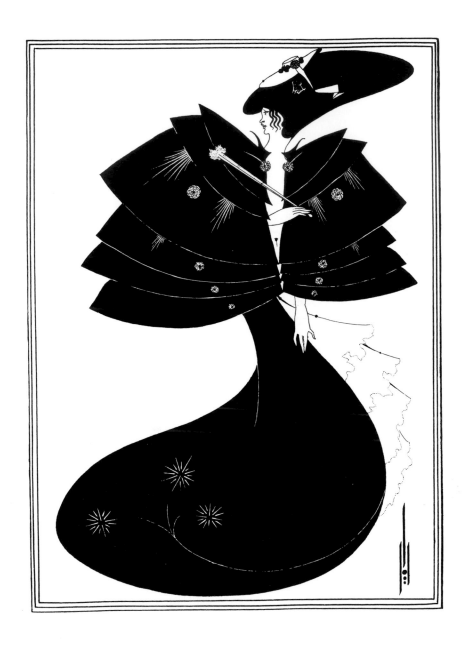

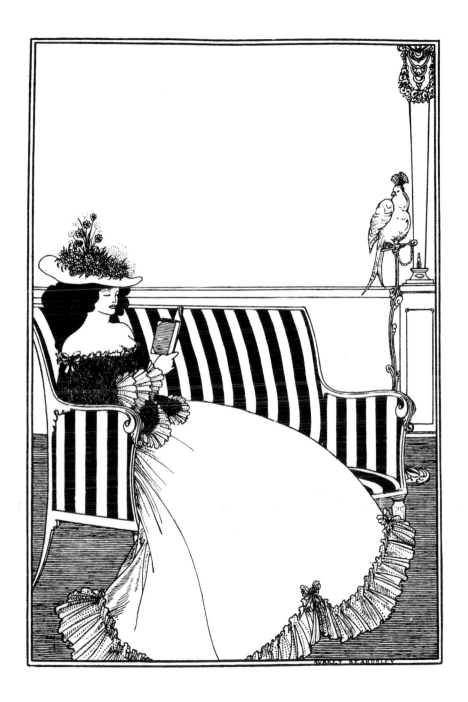

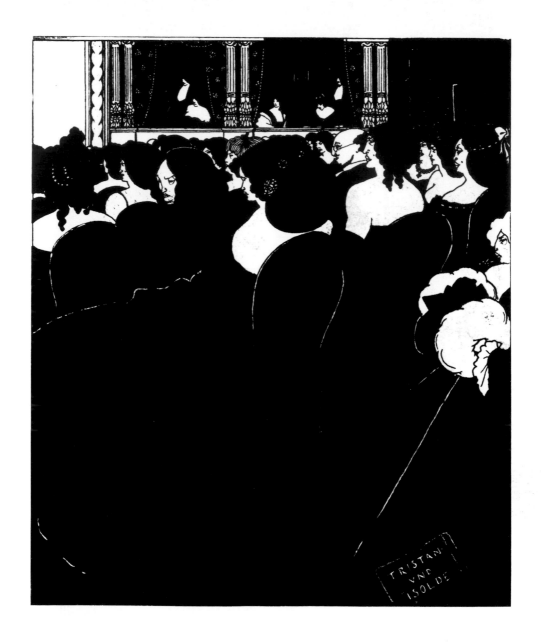

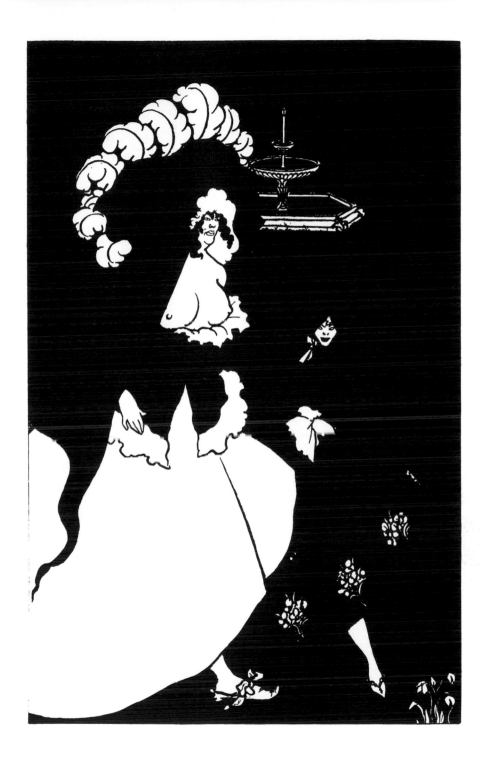

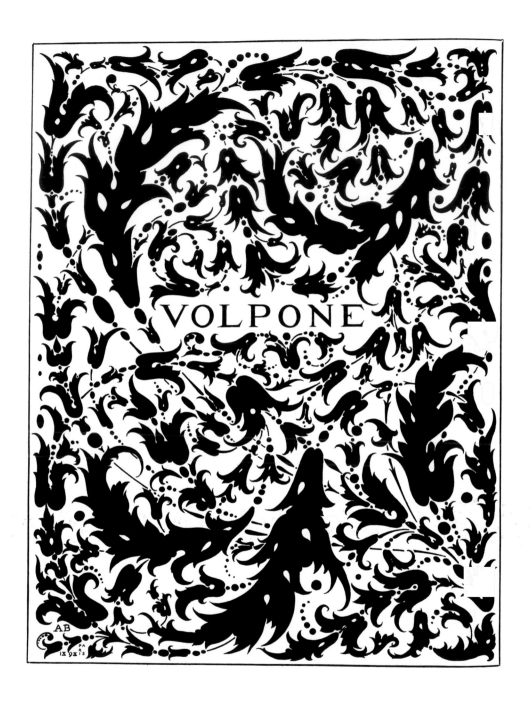

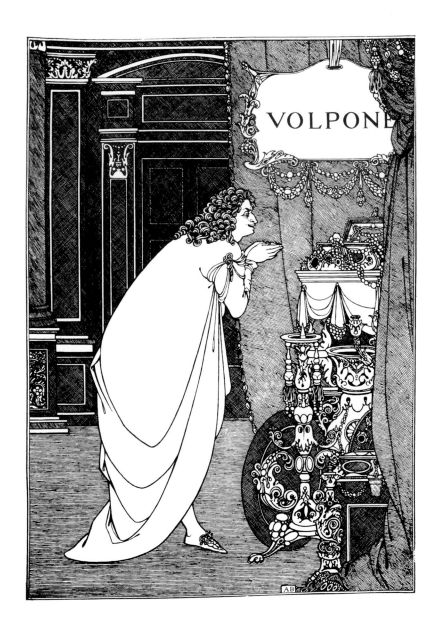

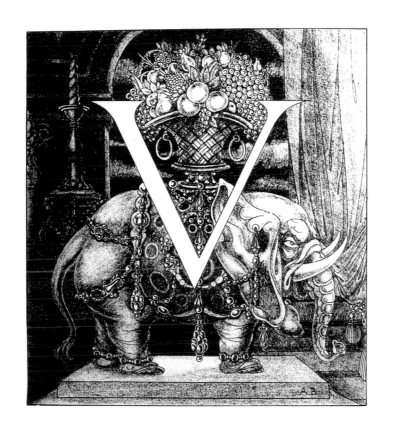

CAPTIONS

Front Cover: THE BLACK CAPE *1894.* Design conquers nature: what body could inhabit this swirling abstraction?

Front Jacket Flap: SELF PORTRAIT IN THE FORM OF A BUST *1896.* Aubrey Beardsley as he would like to have been - the man of elegance and fashion.

Title page: AUBREY BEARDSLEY'S EX LIBRIS *1897.* Design for the artist's own book-plate which he re-used for this friend Herbert Pollitt.

Pages 8 - 17: Vignettes and grotesques from BON-MOTS *1893-4.* Classical ornaments rendered literally grotesque - the goblin and the foetus, the Pierrot and a spider as if from the imagination of Odilon Redon. Beardsley at his most weirdly playful.

Pages 18 - 19: Chapter Headings from LE MORTE DARTHUR *1893-4.* Beardsley's medieval period, consciously based on Burne-Jones' pre-Raphaelite style. Burne-Jones was one of the first to recognise and encourage Beardsley's talent (1891).

Pages 20 - 21: Chapter Headings from LE MORTE DARTHUR *1893-4.* The peacock was a leading symbol (of vanity) in *Art Nouveau,* the style of formalised decoration Beardsley helped pioneer and promote in the 1890's. Note the stylish curves and stark simplification.

Pages 22 - 23: Chapter Headings from LE MORTE DARTHUR *1893-4.* The hair is like the tendrils of a plant, the faces generalised without character and the whole image flattened into a pattern of shapes. Only drama remains.

Pages 24 - 25: Chapter Headings from LE MORTE DARTHUR *1893-94.* Remark the exaggerated length of the angel's wings: the figure is sexless, but the twining upthrusting briars suggest a masculine potential. The hair is brushed forward in a fringe like Beardsley's own.

Page 26: How Queen Guenever Made Her a Nun, from Le Morte Darthur 1893-94. The first real example of the solid blacks which are so much typical a feature of Beardsley's early style.

Page 27: Border for the list of Pictures, from Salome 1894. Beardsley dearly loved a swirling skirt. Now the girl's hair is coiled into roses, helping to unify the pattern still further.

Page 28: The Stomach Dance, from Salome 1894. Beardsley at his most overtly outrageous and provocative. Salome is in full seductive mode, flaunting herself within the concealing/revealing cloak which swirls around her. A hideous demon of desire calls the tune.

Page 29: Enter Herodias, proof from Salome 1894. The first version of this illustration which Beardsley had to clean up by adding a fig-leaf to the standing figure at right. Censorious eyes failed to notice the phallic candle-sconces and the pronounced erection of the figure on the left.

Page 30: The Toilet of Salome, first version from Salome 1894. This version was rejected because the seated youth front left, was thought to be too degenerate. The whole composition is in fact coded in different ways to suggest masturbation.

Page 31: The Toilet of Salome, from Salome 1894. The second version, to replace the earlier languorous half-naked scene. Here Beardsley has simplified the drawing so radically as to have dispensed with Salome's arms. The hat matches the dressing table in the height of fashion.

Page 32: The Woman in the Moon, frontispiece from Salome 1894. Very Egyptian in mood, spare and austere. Beardsley teases the author by caricaturing Wilde as the Woman in the Moon. Interestingly, most of the action takes place at the top of the frame. The setting is radically abstract.

Page 33: John and Salome 1894. Not published until 1907 in a portfolio illustrating Salome. Note the 'hairy' fringe of the Baptist's robe and the tenseness with which these two confront each other; desire and restraint permeate the picture.

Page 34: A PLATONIC LAMENT, from SALOME *1894*. Herodias' page laments the death of his friend, the Young Syrian Captain, who was so in love with Salome that he killed himself when he heard of her passion for John the Baptist. Wilde's moon-face edges in to the right above a topiary tree like a pyramid. Another amazingly empty and abstract picture.

Page 35: THE PEACOCK SKIRT, from SALOME *1894*. Here the influence of Whistler's great Peacock Room, designed and decorated for Frederick Leyland in 1876, is strongest.

Page 36: THE KISS OF JUDAS *1893*. An illustration for 'The Pall Mall Gazette', describing the legend that the children of Judas prowl the world seeking to kill with a kiss. Compare the construction of 'A Platonic Lament' on Page 34.

Page 37: THE CLIMAX, from SALOME *1894*. Based on Beardsley's 1893 drawing for *The Studio* which had caught Wilde's eye, but much simplified, with all the hair-line details eliminated. Notice the thick coiling blood which equally seems to fountain upwards as to fall from the head.

Page 38: THE BURIAL OF SALOME (CUL-DE-LAMPE) from SALOME *1894*. Burying Salome in a gigantic powder jar and puff was not in Wilde's play script. This is Beardsley taking camp liberties. No wonder Wilde is supposed to have remarked rather cruelly of Beardsley, "even his lungs are affected".

Page 39: LUCIAN'S STRANGE CREATURES, for LUCIAN'S TRUE HISTORY *1894*. Not used, and not published until 1906 by Smithers. Here rides the foetus central stage. Wilde said that behind Beardsley's grotesques "there seemed to lurk some curious philosophy."

Page 40: BIRTH FROM THE CALF OF THE LEG, for LUCIAN'S TRUE HISTORY *1894*. Again not used, nor published till 1906. A prime example of Japanese influence in the bold cropping of the action. A tough image, strange and original.

Page 41: Invitation card for John Lane's SETTE OF ODD VOLUMES SMOKE *1895*. A light design, a vignette typically open-ended in space. The puffing Pierrot is shown oddly three-quarters from the back.

Page 42: THE MASK OF THE RED DEATH *1894*. The fourth of four illustrations for *The Works of Edgar Allan Poe,* the stuff of Hammer Horror films rendered sublimely decadent.

Page 43: THE MURDERS IN THE RUE MORGUE *1894*. The first of the four drawings to Poe's tales. Note Beardsley's taste for hanging tassels and drop ear-rings. The murders were actually committed by an orang-utan - Beardsley's beast is a foul creature of the imagination.

Page 44: Design for front cover of THE YELLOW BOOK VOL I *April 1894*. Printed in black on yellow cloth boards. Here the masked ball turns decidedly sinister in a design of startling flatness. Look how the woman's hat is carved out of the surrounding blackness, regard her formalised hair and the bold *pointilliste* dots of her dress. Severe.

Page 45: Design for the prospectus and the front cover of THE YELLOW BOOK. Withdrawn when Beardsley was dismissed as art editor of *The Yellow Book* after Wilde's arrest. An enlightened 'Beardsley Woman', as they were called, is being read to by a faun.

Page 46: Design for the front cover of the prospectus of THE YELLOW BOOK *April 1894*. This is the quintessential 'Beardsley Woman': independent, elegant, out on her own at night, intellectually discerning, but above all enterprising. She knows what she wants, and at the risk of shocking society, she'll get it.

Page 47: Design for the front cover of THE YELLOW BOOK VOL II *July 1894*. Not the usual refined Beardsley type, this girl has thicker, more obviously sensual lips and rather extravagant hair. Eroticism is implied rather than stated. The background design is pure *Art Nouveau*.

Page 48: ALI BABA *1896*. The lure of the East: a front cover design for an unpublished edition of *The Forty Thieves*. An interesting combination of large forms and close detailing. The lettering is Beardsley's own and the closest he got to true Roman lettering.

Page 49: ALI BABA IN THE WOOD *1896*. Note the amazing technique of using different sized white dots (the white of the paper itself, not applied white) to describe the foliage of the wood, the tree-trunks drawn in with close parallel lines.

Page 50: ET IN ARCADIA EGO, for THE SAVOY, *1896*. An old *roué* or dandy, stepping carefully (and looking most out of place) in some pastoral heaven. The title, which means, *I too, am in Arcadia* is often taken to refer to Death as the intruder in Paradise.

Page 51: Frontispiece to THE FULL AND TRUE ACCOUNT OF THE WONDERFUL MISSION OF EARL LAVENDER, WHICH LASTED ONE NIGHT AND ONE DAY by John Davidson *1895*. A beautiful drawing about the delights of flagellation (which Beardsley does not seem to have enjoyed personally). The setting, a small typically Victorian room, is treated with classical economy and grandeur.

Page 52: LYSISTRATA SHIELDING HER COYNTE *1896*. The eight drawings (pages 52-59) for Aristophanes' sexual comedy *Lysistrata* were done in the Spread Eagle Hotel in Epsom, Surrey, in the summer of 1896. They show the hours of study Beardsley devoted to Greek vase painting in the British Museum. Unabashedly erotic, they are also very funny.

Page 53: LYSISTRATA HARANGING THE ATHENIAN WOMEN *1896*. There are no visible backgrounds on view, yet the picture space is convincing and what Beardsley conveys with line and dot is exquisitely descriptive.

Page 54: THE LACEDAEMONIAN AMBASSADORS *1896*. By the massive exaggeration of their private parts, Beardsley brilliantly conjures the groaning ache of sexual frustration. A sick young man, it seems likely he knew all about it.

Page 55: LYSISTRATA DEFENDING THE ACROPOLIS *1896*. Lysistrata will evidently stick at nothing, however lavatorial. The humour is bawdy but verges on the smutty. It also refers to Japanese erotic prints.

Page 56: THE EXAMINATION OF THE HERALD *1896* and Page 57: THE TOILET OF LAMPITO *1896*. Two more illustrations for Lysistrata. The proud herald (one hesitates to call him boastful) has a rather epicene look; Beardsley often made his characters sexually ambivalent. *The Toilet of Lampito* is both funny and sexy. Cupid with his quiver of arrows is evidently enjoying himself, eyes closed and toes curled in ecstasy, and a powder-puff makes another appearence.

Page 58: CINESIAS ENTREATING MYRRHINA TO COITION *1896*. A superb piece of design, richly decorated yet powerfully simple, the image is packed with energy and movement.

Page 59: TWO ATHENIAN WOMEN IN DISTRESS *1896*. Lysistrata, who has inspired the women of Athens to refuse their husbands all sexual favours (hence the frustration), discovers the women deserting her to find and and solace their menfolk. Here one descends by pulley, another on a sparrow's back. The arm breaking through the top of the frame is odd but dramatic.

Page 60: MESSALINA RETURNING FROM THE BATH *1897*. Is Messalina truly evil or simply magnificently grumpy? Whichever, this is no happy little lady, and Beardsley has drawn her with an unusually thick outline. Illustration to the *Sixth Satire* of Juvenal.

Page 61: JUVENAL SCOURGING WOMAN *1896*. Published in 1906 by Smithers in *An Issue of Five Drawings Illustrative of Juvenal and Lucian*. Taken from Juvenal's *Sixth Satire*, it is in the style of the *Lysistrata* drawings, though rather strongly misogynistic in feel.

Page 62: BATHYLLUS POSTURING *1896* and Page 63: BATHYLLUS IN THE SWAN DANCE *1896*. Two further illustrations for Juvenal's *Sixth Satire*. Bathyllus was an effeminate male dancer, very popular with the Romans (by then far more truly decadent than the British of the Naughty Nineties). Beardsley in Greek vase mode: thoroughly indecent and suggestive.

Page 64: THE IMPATIENT ADULTERER *1896*. The seamiest illustration for Juvenal's *Sixth Satire (Against Woman)*, and not published until recently. The adulterer keeps himself in a state of readiness: who but Beardsley would have thought to depict him with toes curling in impatience?

Page 65: COUNT VALMONT *1896*. Illustration to *Dangerous Liaisons* by Choderlos de Laclos, published in *The Savoy No8* December 1896. The novel's central character is shown apparently naked under his off-the-shoulder cloak. What does the hand gesture signify? Illicit passions?

Page 66: THE CAVE OF SPLEEN, from THE RAPE OF THE LOCK *1896*. There is hardly a bare centimetre in Beardsley's camp rococo style, all close sinuous lines and curlicues. Strange creatures, half-human, half-furniture abound and the foetus crops up a couple of times. Heroic-comical like Pope's poem it illustrates.

Page 67: THE DREAM, from THE RAPE OF THE LOCK *1896*. Virtuoso filigree tracery, all brilliantly orchestrated dots. Beardsley was a master of this stipple technique. The decorative motifs derive from Louis XVI and the Aesthetic period, while the courtier is dressed like a 1740s ballet dancer, in rather buttocky pantaloons.

Page 68: THE ABBE *1896*. A drawing of the central character, first called Abbé Aubrey then the Chevalier Tannhauser, and no doubt an autobiographical fantasy, in Beardsley's own unfinished erotic novel *Under the Hill*. Splendidly be-tasselled and ornate.

Page 69: THE BARON'S PRAYER, from THE RAPE OF THE LOCK *1896*. The Baron, long a combatant in love's lists, offers up a prayer at his altar to love that he might be given a lock (the very lock of the poem's title) of the beloved Belinda's hair.

Page 70: THE BATTLE OF THE BEAUX AND THE BELLES, from THE RAPE OF THE LOCK *1896*. Just the kind of image that *Punch* would challenge us to write a caption for: He said...and she replied... Amazing variety of tone and texture in these dots and close-laid lines. The chair is a typical rococo design of the mid-18th century.

Page 71: THE TOILET OF HELEN *1896*. Helen is the Venus figure from Beardsley's novel *Under the Hill,* and Tannhauser's female counterpart. To her right and seated is the fat manicure and fardeuse, Mrs Marsuple. The proliferation of line and pattern is here made to seem somewhat sinister; regard the malevolent goblins at the forefront.

Page 72: THE BILLET-DOUX, from THE RAPE OF LOCK *1896*. One of the prettiest of Beardsley's drawings, rather too sweetly sentimental for some tastes. The composition is centrally organised and symmetrical, the scene's emotion rather predictable. And the hand is oddly paraphrased.

Page 73: THE TOILET, from THE RAPE OF THE LOCK *1896*. In Beardsley's lifetime it was THE RAPE OF THE LOCK drawings which were most deeply admired, perhaps because of the technical virtuosity required to imitate an engraving style in pen and ink. (The French 18th century engravers were his model.) And what a mastery of textures!

Page 74: THE FRUIT BEARERS *1895*. Cloven-hoofed and horned, the first bearer has a distinctly demonic aspect. Another illustration for *Under the Hill,* published in *The Savoy* in January 1896.

Page 75: A REPETITION OF TRISTAN AND ISOLDE *1896*. Published in *The Savoy,* this rich dark drawing was meant to celebrate Chopin before it was commandeered for Wagner. More heavily worked than usual - a new departure?

Page 76: Design for front cover of prospectus of THE SAVOY, No1 *1895*. The suggestive fold in John Bull's crutch caused the inevitable offence, but not before thousands of copies of this prospectus had been distributed.

Page 77: Design for page preceding contents list of THE SAVOY, No1 *1895*. The offending prospectus design has been cleaned up, and John Bull's evident manhood removed. Given a few more swags and tassels, he is a tamed and more effeminate creature altogether.

Page 78: Design for front cover of THE SAVOY, No1 *1896*. This is the original design in which the nearly-naked page urinates derisively on a copy of the *The Yellow Book* in the grass. When the drawing actually came to be published, Smithers had done away with not only the book, but the instrument of defilement.

Page 79: Design for front wrapper of THE SAVOY, No5 *1896*. The drawing is signed Giulio Floriani as a joke. The atmospheric setting recalls certain Watteau paintings. A secret assignation?

Page 80: Titlepage to THE SAVOY NOS 1 AND 2 *1896*. A bold outline and then invention let rip in the design and decoration of the costumes. Reproduced in gold on violet cloth and vellum in different editions.

Page 81: Frontispiece of JUVENAL *1895*. Two liveried monkeys carrying an old type in a sedan chair through the streets of what looks like Regency London even if intended to be Imperial Rome. Beardsley's last illustration for *The Yellow Book*.

Page 82: THE SCARLET PASTORALE *1895*. A clever study in arrested movement: the dancer is frozen but dynamic, and full of potential steps. Behind him is a drop curtain of masqueraders.

Page 83: Frontispiece for PLAYS by John Davidson *1894*. This cast of dodgy characters is supposed to include Mabel, Beardsley's sister, in the nude, Henry Harland (the literary editor of *The Yellow Book*) and Oscar Wilde. You can spin many a scandalous narrative between them, but observe the daring abstraction of the landscape background.

Page 84: THE BATHERS *1895*. Illustration for THE SAVOY No1 To accompany Arthur Symons' article *Dieppe: 1895*. Beardsley visited Dieppe with Symons, but tended to stay indoors and invent rather than draw from life on the beach. The odd central figure is supposed to be the actress Cléo de Mérode.

Page 85: Second frontispiece to AN EVIL MOTHERHOOD *1896*. This was a substitute for *Black Coffee,* which should have appeared in *The Yellow Book.* Instead Beardsley did a portrait of the author Walter Ruding as a dissipated long-haired youth at the fag end of the day (and of a century), with a fierce mother overseeing him.

Page 86: THE COIFFING, illustrating Beardsley's poem THE BALLAD OF A BARBER *1896*. Reproduced with the poem in *The Savoy No3*. The barber falls in love with the 13 year old princess, kills her (to possess her) and is hanged. Note the remarkable pyramidal composition, culminating in the Virgin and Child statuette on the sideboard. A great and disturbing drawing.

Page 87: LE DEBRIS D'UN POETE *c1892*. A very early self-portrait in the Japonesque style that Beardsley evolved. His dissatisfaction at being a clerk with the Guardian Life Insurance Company is conveyed by the fact that the slouching figure at the high desk has his back to us.

Page 88: A FOOTNOTE, from THE SAVOY, No 2 *1896*. Another self-portrait, this time an older Beardsley tethered to a sculpted torso of Pan. He has made his ears look pointed and faun-like to emphasize his kinship with the pagan god. A declaration of wickedness and immorality.

Page 89: DON JUAN, SGANARELLE, AND THE BEGGAR *1896*. Illustrated in *The Savoy No.8*. Beardsley makes Don Juan into a Pierrot (one of the figures he himself identified with), and this figure and the cloaked and cane-carrying Sganarelle were inspired by Watteau's painting *The Italian Comedians*.

Page 90: PORTRAIT OF HIMSELF *1894*. The artist snuggled in a dark tasselled retreat. The canopied bed resembles the opening of the female sex, with the white of the sheet and pillow forming the male sex penetrating the darkness.

Page 91: THE DEATH OF PIERROT *1896*. Another hugely phallic image that doubles as a self-portrait. Beardsley as Pierrot lies slumped and dead a-bed. The skirts of the shushing girl at the bottom of his bed form the outline of a scrotum and detumescing penis. What is he trying to say?

Page 92: GARCONS DE CAFE *1894*. A group portrait of the waiters of that quintessential Nineties hang-out, The Café Royal. Composed of saturated black and bare white it looks like a woodcut and is a tribute to the prints of Nabi artist Felix Valloton. It is equally reminiscent of the posters produced by the Beggarstaff Brothers (James Pryde and William Nicholson) in the 1890s.

Page 93: THE NEW STAR, from THE RAPE OF THE LOCK *1896*. The cul-de-lampe or tail-piece of Pope's poem. A carnival feel to this image, and the dawn of enlightenment or new hope. The costume suggests the period of Louis XIV.

Page 94: The Fall of the House of Usher 1894. Another drawing, in Beardsley's minimal Japonesque style, after the writings of Edgar Allan Poe. Moody as hell.

Page 95: Cover design for A Book of 50 drawings 1897. Beardsley collected his best work together before he died in a consciously retrospective manner. The design, when printed in gold on crimson cloth, lost something of its black and white incisiveness.

Page 96: CARICATURE OF WHISTLER c1893-4. Whistler is posed on a frail-looking garden seat, pointing at a butterfly, his own emblem. He was disparaging of Beardsley until he saw some of the late work, when he apologised and admitted the young man's genius. Unbearably moved, Beardsley burst into tears.

Page 97: THE BLACK CAT 1894. The second of four illustrations to E. A. Poe. The beast looks menacing and evil, more pug dog than cat. But look at its startling white powder-puff chest blazon: Beardsley could do things with India ink others would not attempt.

Page 98: INVITATION CARD TO THE OPENING OF THE PRINCE'S LADIES GOLF CLUB *1894*. Somewhat out of the ordinary for an invitation: a 'Beardsley Woman' rests nonchalantly on a golf club as though it were a fashionable cane, while a Pierrot selects a putter for her. A splendid piece of silhouette work.

Page 99: Mrs Patrick Campbell *1894*. Exquisite in its simplicity and candour. It is no surprise to discover that Oscar Wilde owned the drawing before it was bought by the National Gallery of Berlin. Wilde arranged for Mrs Campbell to sit to Beardsley. When it was published in Volume 1 of *The Yellow Book,* the drawing caused great controversy as an insulting caricature.

Page 100: Design for front cover of The House of Sin by Vincent O'Sullivan *1897*. Coarse and snouting, this winged lady-porker is completely unexpected in the context of fine book design. Printed in gold on vellum-coloured boards: Beardsley being Surreal.

Page 101: Grotesque from the Bon-Mots of Smith and Sheridan *1893*. The foetus as architectural cap-stone, as medieval gargoyle even. Here Death gnaws at the brain-pan of the ornamental unborn, and a butterfly (symbolising the soul?) flies free. Beardsley at his most ghoulish.

Page 102: Cover design for The Rape of the Lock 1896. Printed in gold on bright turquoise cloth, this design is beautifully stylised and elaborated. Beardsley loved dressing tables (his altars). Here an oval looking-glass with scissors is flanked by wildly branching candle-sticks.

Page 103: The Slippers of Cinderella *1894*. An ink drawing later coloured in by the artist in green and scarlet water-colour. Beardsley was never the subtlest of colourists. His genius lay in making black-and-white design *appear* to dance with colour.

Page 104: The Black Cape, from Salome *1894*. A replacement for a more *risqué* drawing, Beardsley descibed this as "simply beautiful, but quite irrelevant".

Page 105: Cover for Leonard Smithers' Catalogue of Rare Books *1895-6*. Beardsley's eclecticism is much in evidence: a modern woman is anachronistically *décolleté* and sits on a Regency sofa.

Page 106: The Wagnerites *1894*. Possibly Beardsley's blackest composition, done for *The Yellow Book Volume III*. He loved Wagner, but here we see the audience not the stage. What must Toulouse-Lautrec, who liked and admired the young Englishman's talent, have thought of this radical use of black?

Page 107: MESSALINA RETURNING HOME *1895.* Not quite the grump of the second version (compare page 60) but still pretty fearsome to meet on a dark night. And Beardsley leaves us in no doubt as to the darkness of the night.

Page 108: Design for the front cover of BEN JONSON HIS VOLPONE *1898.* Reproduced in gold on turquoise cloth or in gold on vellum. The recklessly magnificent swirl of the design seems to many commentators to anticipate Abstract Expressionism - compare Jackson Pollock.

Page 109 Design for the front over of VERSES by Ernest Dowson *1896.* What crucial restraint and surging elegance! In gold parchment board this *Art Nouveau* design is economic but exquisite.

Page 110: VOLPONE ADORING HIS TREASURE *1898.* Frontispiece for *Volpone,* done in the style of 17th century engraving. Brian Reade calls it "one of the most exalted achievements of penmanship in the history of art".

Page 111: Design for the initial V of VOLPONE *1898.* This is Beardsley at his most baroque, modelled not outlined, full of weight and odd highlights. The *Volpone* commission was the last he undertook and was incomplete at his death.

Back cover flap: CUL-DE-LAMPE from Beardsley's poem THE BALLAD OF THE BARBER *1896.* Beardsley's maternal grandmother was a silhouette artist, but did he ever see her work? Here the light of life is about to go out with the hangman's noose.

Back cover: GROTESQUE from the BON-MOTS OF LAMB AND JERROLD *1893.* A final back view: Pierrot, looking rather like Whistler, going home, tasselled cane in hand. Beardsley once quipped that he had caught cold by leaving the tassel off his cane.

Endpapers: Design based on various of Beardsley's drawings for the KEYNOTES series 1895-6.

FURTHER READING

BEARDSLEY by Brian Reade, London 1967. BLACK AND WHITE by Brigid Brophy, London 1968. THE BEST OF AUBREY BEARDSLEY by Kenneth Clark, London 1979. BEARDSLEY by Simon Wilson, Oxford 1983. AUBREY BEARDSLEY by Stephen Calloway, London 1998. AUBREY BEARDSLEY: A CENTENARY CELEBRATION by Simon Wilson and Linda Zatlin, Japan 1998.